IMAGES
of America

OGDEN
AND
SPENCERPORT

IMAGES
of America

OGDEN
AND
SPENCERPORT

Ogden Historical Committee

ARCADIA

First printed in 2002.

Published by Arcadia Publishing,
an imprint of Tempus Publishing, Inc.
2A Cumberland Street
Charleston, SC 29401

Printed in Great Britain.

Library of Congress Catalog Card Number: 2002105020

For all general information contact Arcadia Publishing at:
Telephone 843-853-2070
Fax 843-853-0044
E-Mail sales@arcadiapublishing.com

For customer service and orders:
Toll-Free 1-888-313-2665

Visit us on the internet at http://www.arcadiapublishing.com

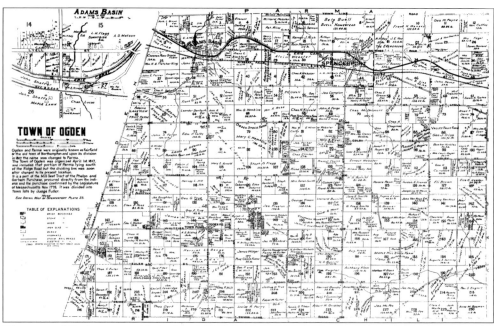

This map of Ogden was published in 1902.

CONTENTS

ACKNOWLEDGMENTS

In January 2000, Supervisor Gay Lenhard and the Ogden Town Board appointed the Ogden Historical Committee. The members of the committee took the town board's charge to "document the town's history" by working with Arcadia Publishing to produce an edition in the *Images of America* series entitled *Ogden and Spencerport*.

Committee members met more than 15 times to review and select the approximately 200 pictures used in this book. Several hundred pictures were reviewed, including the extensive collection of the Ogden Historical Society.

Ogden Farmers' Library director Pat Uttaro was a major contributor, typing captions and scanning all the photographs. Fred Holbrook authored many of the captions and other text while keeping in contact with Arcadia editor Pam O'Neil. Helen Moore chaired the Ogden Historical Committee and helped keep it on task. Ken Beaman, Lewis "Bud" Nichols, Verne and Betty Voorheis, Jane Weber, Ben Morgan, and Ray and Bette Spencer all spent considerable time and effort on this project.

Earl E. White's *150 Years in Ogden, 100 Years in Spencerport* (published in 1967) was a valuable resource. The 1990 commemorative issue dedicated to the Spencerport Volunteer Fire Department was also helpful. Many other individuals supplied photographs, reminiscences, and helpful suggestions to the members of the committee.

We hope that we have fulfilled the request of the Ogden Town Board and, more importantly, that we have contributed a sense of the past to the present residents of Ogden and Spencerport.

—The Ogden Historical Committee

INTRODUCTION

American history for the first 100 years was the story of the frontier. New England settlers saw western New York as the frontier in the early 1800s, and they were Ogden's first residents. George W. Willey, the four Colby brothers from Connecticut, and the Trues from New Hampshire were followed by others until the Erie Canal was completed in 1825.

Gov. Dewitt Clinton's "ditch," as the Erie Canal was called, was one of the great stories of the 19th century and became the principal way to cross the Appalachian Mountains into the interior of the continent. After 1825, the small settlement in Ogden Center and the sparsely settled parts of Ogden saw the focus of town and commercial life shift to the canal and the growth of Spencerport and Adams Basin.

Ogden and Spencerport, along with Adams Basin and Town Pump, are revealed in their formative period in the photographs displayed in this volume. The Erie Canal, the railroads, and now the highways (especially Route 531) have had their impact on the community. From an agricultural society with small settlements at the train shipment points, the area has developed since World War II as a suburban area and bedroom community for Rochester and Monroe County businesses.

This volume explores that history, primarily in pictures. The Ogden Historical Committee hopes you enjoy the story.

One
THE ERIE CANAL

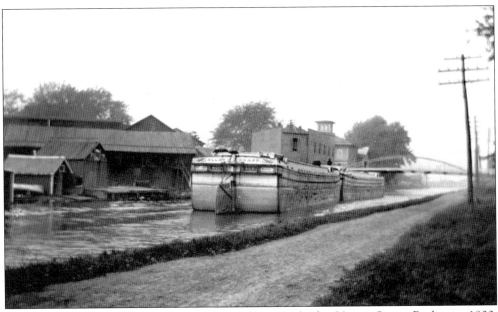

Canal boats heading west on the Erie Canal approach the Union Street Bridge in 1900. Buildings crowd the canal bank east of Union Street.

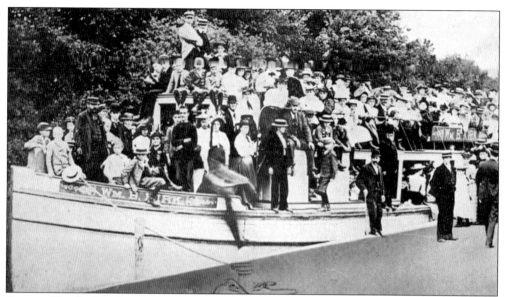

Outings like this one were common on the Erie Canal in the late 1800s. People would spend their Sunday afternoons riding on one of the many boats that plied the canal, enjoying picnics on the banks of the canal and wearing their Sunday best.

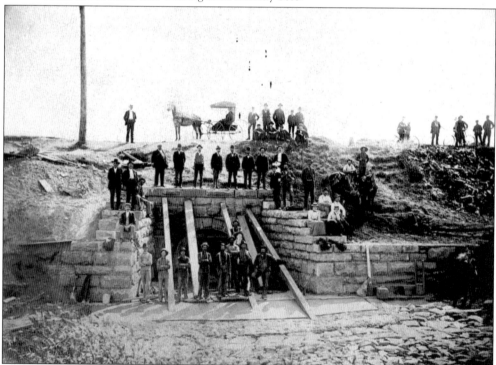

Culvert construction along the Erie Canal is shown in this 1910 photograph taken near Adams Basin. It appears to be a Sunday or a holiday, as most men are dressed in suits and a few women are present. During this period, the canal was rerouted, enlarged, and renamed the Barge Canal. Many of the bridges in the area—including those on Gillett, Gallup, and Trimmer Roads and Martha Street—date from 1909–1910.

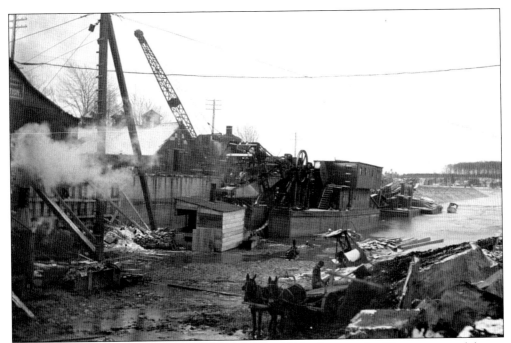

Canal construction activity is shown in this *c.* 1910 photograph. The cranes and heavy equipment were steam driven. Smaller equipment, such as the wagon in the foreground, was drawn by mule teams.

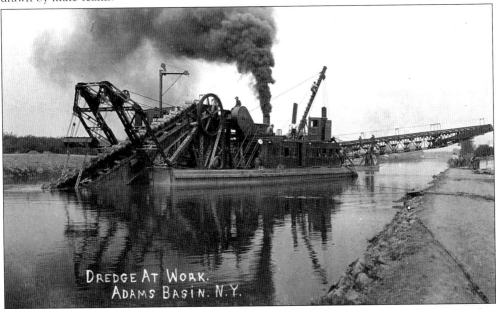

DREDGE AT WORK.
ADAMS BASIN. N.Y.

In 1900, the Canal Commerce Committee recommended that the Erie Canal be enlarged to accommodate larger barges, leading to the construction process shown in this 1912 photograph of a dredger at work near Adams Basin. This dredger worked around the clock and made a great deal of noise. Former Ogden historian Earl White wrote, "It was a wondrous sight in Adams Basin and in Spencerport because it was illuminated by electricity" before the village and surrounding area had that improvement.

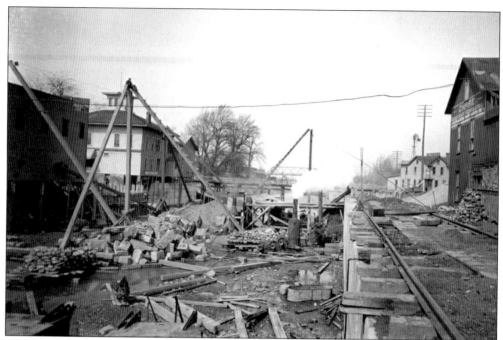

Work is in progress on the canal near Union Street *c.* 1910. The Cottage Hotel is to the right. On the left is the Goff Building, which now houses Spencerport Printing. A temporary bridge is in the background.

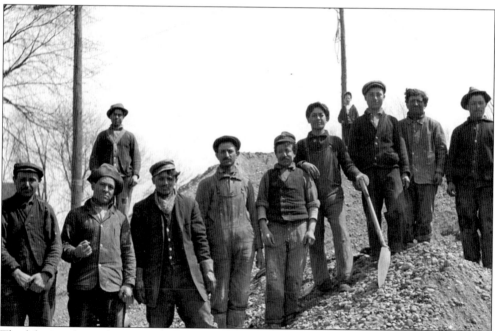

The laborers shown here came to the United States from Sicily, and few could speak English. They made long shelters out of boards covered with sod and performed most of their cooking outside. These men were known for their love of music and could often be heard singing Italian folk songs well into the night.

During the construction of the Union Street bridge, retaining walls of concrete were built on both sides of the canal. Pits for the counterweights for the bridge were poured at the same time.

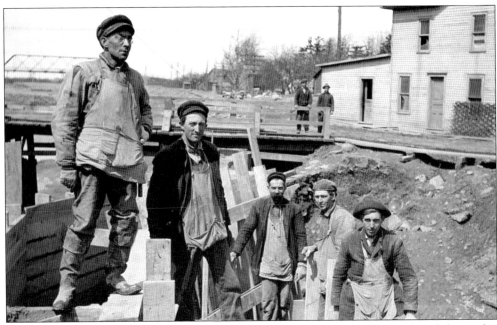

Shown building forms for the foundations of the Union Street lift bridge are, from left to right, carpenters Tom Moden, Al Thaxter, two unidentified men, and Ed Taylor.

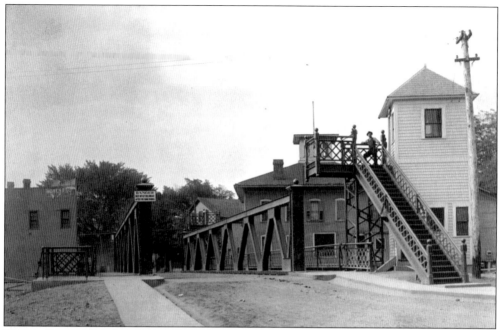

The newly completed Union Street lift bridge is shown in this 1913 photograph along with the bridge tender, pictured at the top of the stairs.

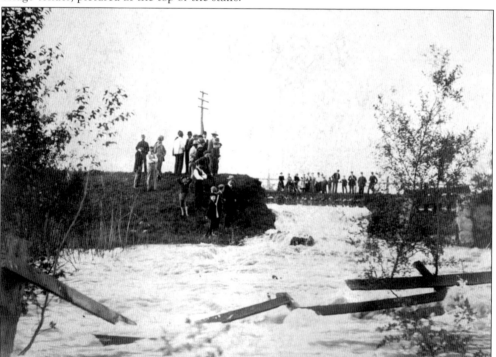

This break occurred in the early 1920s on the north side of the canal east of the Union Street bridge. It was discovered by Charles Waters, age 13, who alerted authorities. Waters was rewarded by the State Canal Authority for his early warning and was given a job as water boy for the summer.

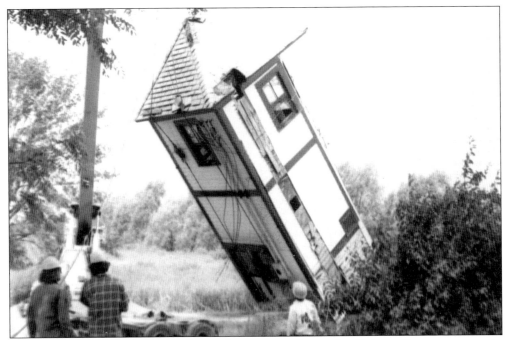

The bridge tender's tower is shown being erected on the Pulver House property in Northhampton Park in the 1970s. The current bridge tender's facility is a more modern brick structure.

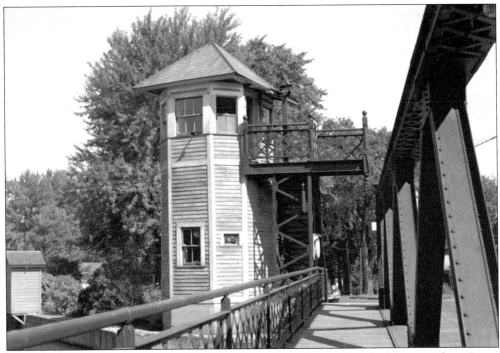

This picture, taken on September 15, 1946, shows the bridge tender's building at Adams Basin.

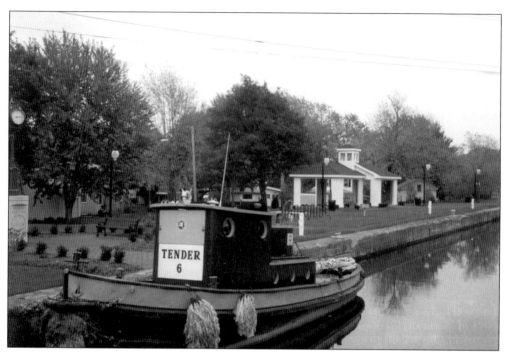

Tender 6 is shown tied up on the north side of the canal east of the lift bridge. Old-timers referred to the yellow-and-blue boats operated by the canal maintenance crew as "the Swiss Navy." This recent photograph shows the completed Merz Park.

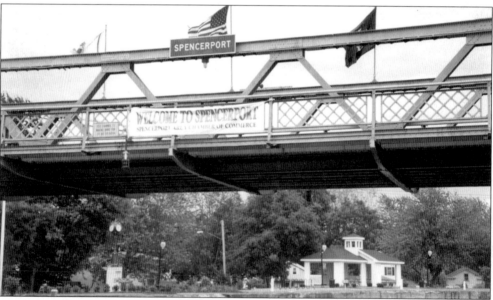

The Union Street lift bridge is pictured in its raised position. The new Merz Park is visible in the background. Former Spencerport mayor Lester Merz donated $100,000 to the village in his will for the purpose of developing a park. The dock and enclosed shelter, plus lights and landscaping, are the result of his gift. The park was dedicated in 2000. Attached to the bridge is a banner furnished by the Spencerport Area Chamber of Commerce.

Two
GOVERNMENT AND
PUBLIC SAFETY

Postmaster Frank Webster poses on "his" side of the postal boxes after sorting the mail. This post office, pictured c. 1907, was located on the east side of Union Street north of East Avenue. Other Spencerport locations were on the north side of Amity Street and, for the last 30-plus years of the 20th century, were next to the bank on the east side of Union Street. Adams Basin still has a post office and, for 20 or more years, so did Town Pump.

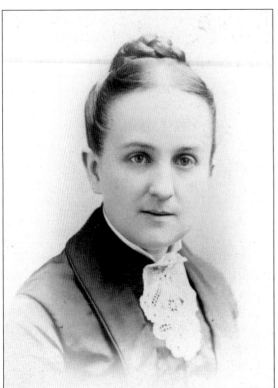

Sarah Lincoln was Spencerport's first postmistress and kept the post office next to the Lincoln House until 1897.

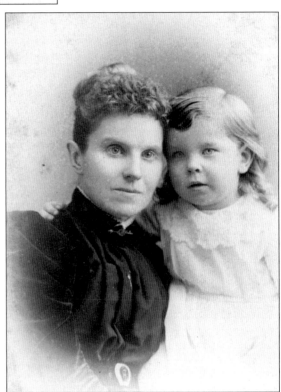

Mrs. A.J. Dewitt worked in the post office for Sarah Lincoln.

Dr. William Slayton, the first president of the village of Spencerport, was elected in 1867, when Spencerport was incorporated by the state legislature. His surname lives on as the name of the street running east from Union Street into the Spencerport Village Plaza.

Ray Austin is shown campaigning for the New York State Assembly in the 1930s. Ray was one of the Austins involved in the drugstore in the village.

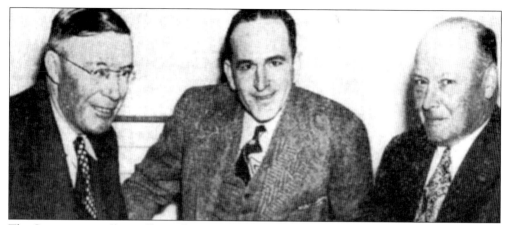

The Spencerport village officers shown in this 1948 photograph are, from left to right, Edward Cosgrove, clerk; Lester Merz, trustee; and Harold "Nick" Hoy, mayor.

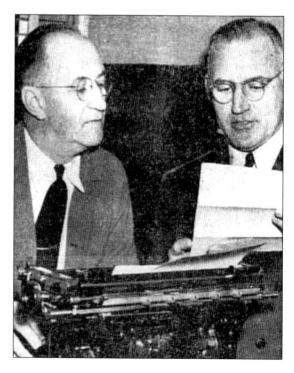

Town of Ogden officers in 1948 are George J. McKinney (left), town clerk, and Kenneth Barclay, supervisor.

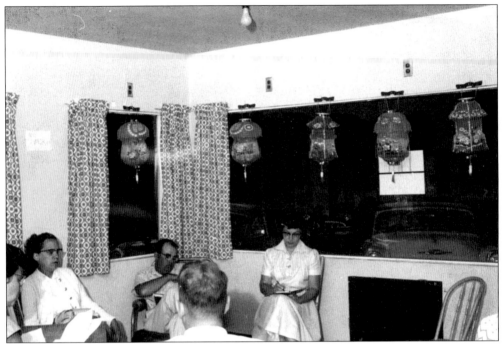

The Spencerport Recreation Association is pictured holding a board meeting in the teen center in 1958. Board members included Mrs. Don Hilfiker, Kay D'Amico, Jim Colby, and Martha Dutton. The center was located in Payne's coal yard. The office building was owned by Erwin Parker.

A. Ross Kitt II was an active politician and businessman in Ogden during the 1950s and 1960s. He served as justice of the peace, town councilman, and supervisor. He also founded General Code Publishing, which was originally located in Spencerport. Kitt has remained active in politics and currently serves on the Board of the Empire Friends, an organization dedicated to supporting and preserving libraries throughout New York State.

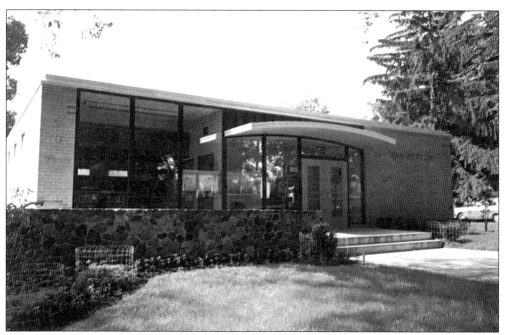

The newly built town hall and Ogden Farmers' Library complex is shown here in the mid-1960s. The building, located on West Avenue, is currently occupied by the Village of Spencerport government offices.

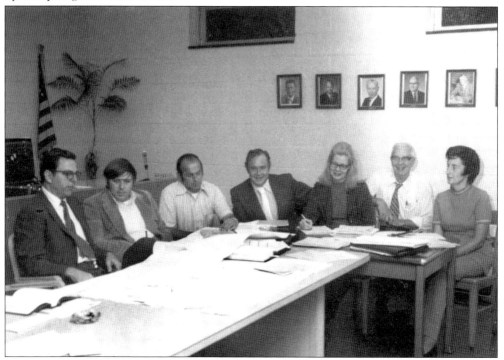

The Ogden Planning Board is pictured at a 1973 meeting. From left to right are Herb Davis, Richard LaCroix, Richard Tallman, Al Frazier, Gail Schott, Charles Moore, and Doris Harrison. Pictures of past town supervisors line the wall.

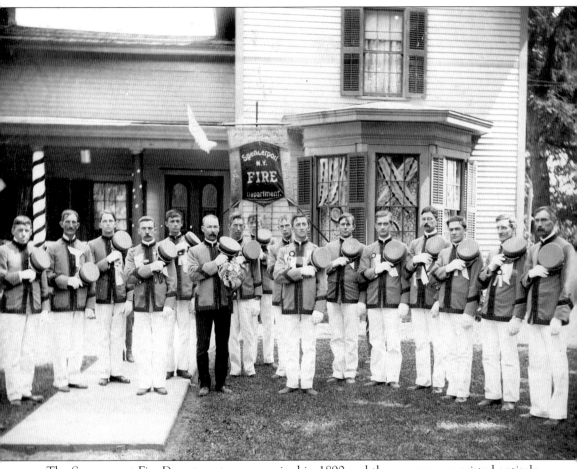

The Spencerport Fire Department was organized in 1890 and then, as now, consisted entirely of volunteers. The C.S. Upton Hose Company is pictured in front of the Vandewater house in 1906 with Chief William J. Ireland (in the dark trousers). Fire was a fearsome threat to villages and homes built almost entirely of wood. A stray spark could easily ignite a nearby building and quickly consume a barn, a home, or sometimes even a whole village. Companies like C.S. Upton were often responsible for saving the lives and livelihoods of their neighbors.

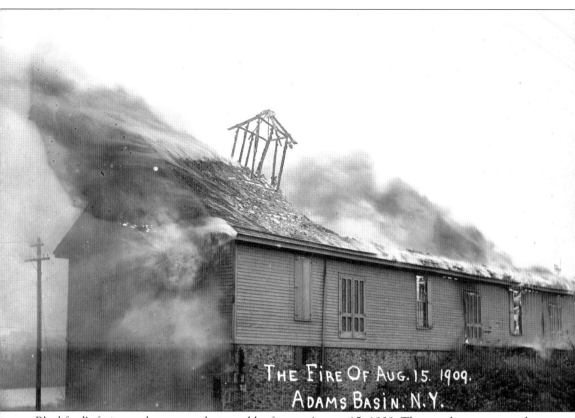

THE FIRE OF AUG. 15. 1909.
ADAMS BASIN. N.Y.

Blackford's fruit warehouse was destroyed by fire on August 15, 1909. The warehouse was used to store apples and other produce prior to shipment to markets in the East. It was believed that the fire was started by the sparks from a passing locomotive. The C.S. Upton Hose Company was one of the units responsible for fighting the fire.

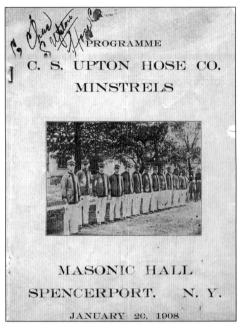

PROGRAMME

C. S. UPTON HOSE CO.

MINSTRELS

MASONIC HALL

SPENCERPORT. N. Y.

JANUARY 20, 1908

Early volunteer companies were frequently named for individuals who sponsored or organized the company. Charles Stanford Upton donated funds to the early fire department and helped create the C.S. Upton Hose Company. The Upton family name is preserved today in Upton Avenue in the village. In addition to fighting fires, the hose company sponsored and performed musical entertainments for residents. This January 1908 program featured light opera, piano, flute, harmonies, and other acts that helped people through the long New York winters.

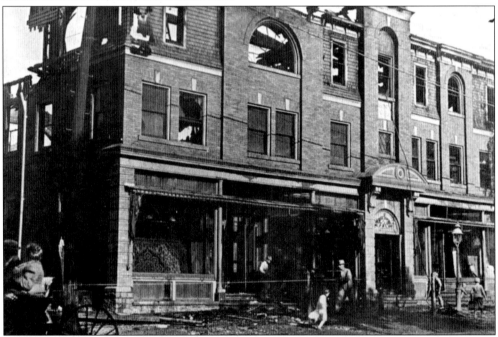

The Masonic Temple is shown after a disastrous 1911 fire. The fire began in an outhouse and spread to nearby buildings, including one owned by Dr. W.S. Milliner that was used to hold drugstore supplies. Hazardous materials such as benzene were kept in Milliner's store house and caused an explosion that allowed the fire to spread into the telephone company offices and eventually into the temple. The temple suffered the loss of its roof, while other buildings were more severely damaged. Such strong streams of water were directed at the fire that Chief William Ireland was swept off the roof when he was caught in a stream. He saved himself by hanging onto a cornice.

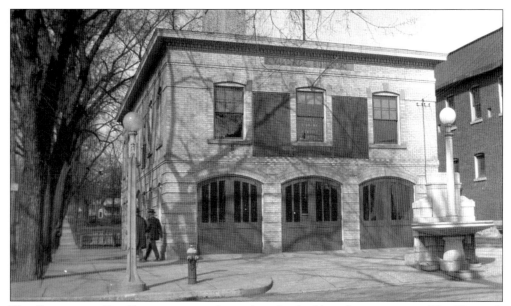

The Spencerport Fire Department was housed in this building for many years. The Women's Christian Temperance Union donated the fountain on the right. Attached to the wall, in a U shape surrounding the center window, are plaques with the names of area men who served in the Spanish-American War and World War I. The plaques are now located at Veteran's Memorial Park. The upstairs of this building housed the Ogden Farmers' Library from the time of its reorganization in 1908 to 1947. The Spencerport Fire Department housed its fire trucks downstairs. The building, fire equipment, and library were all severely damaged by fire in 1948.

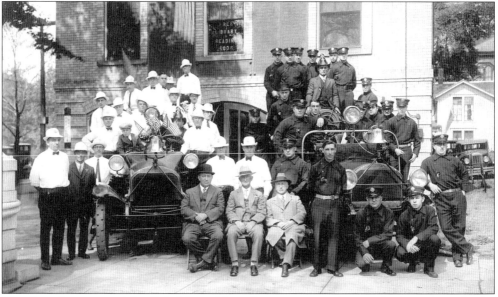

This formal portrait of the C.S. Upton Hose Company was taken in the late 1930s. In the foreground, dressed in coats and ties, are the village board members, including longtime mayor Dr. William Barrett (right). His legacy lives on in Barrett Avenue in the village. The old firehouse is pictured in the background. The building still stands at the corner of Union Street and West Avenue.

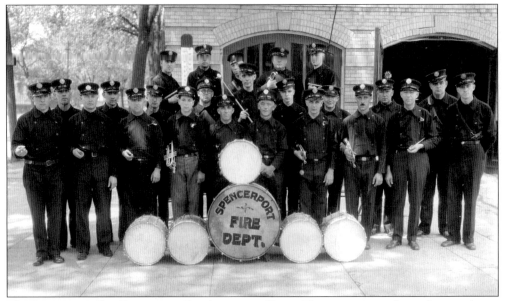

The Spencerport Fire Department Band is pictured here. These men carried on a long tradition of entertaining as well as protecting the general public. The current fire department continues that fine tradition with its firemen's parade and carnival, a staple on the annual event roster of Spencerport.

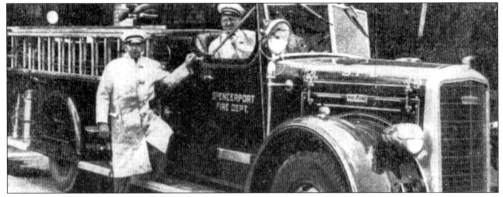

This 1941 Ward LaFrance 500-gallon pumper was damaged in the firehouse fire of 1948 and was then sold to buy newer equipment. It was rescued from the junkyard in 1977, was restored, and is now back in the hands of the Spencerport Fire Department. This 1948 photograph, taken before the December fire, shows Deputy Chief John Osborne (left) and Chief Harold Horton.

This 1948 photograph features the Fire Department Ladies Auxiliary behind a cutout of the famous Ward LaFrance pumper. From left to right are Mrs. Roy Garrison, Katherine Anne Vincent, Anne Lamberson, and Helen Horton.

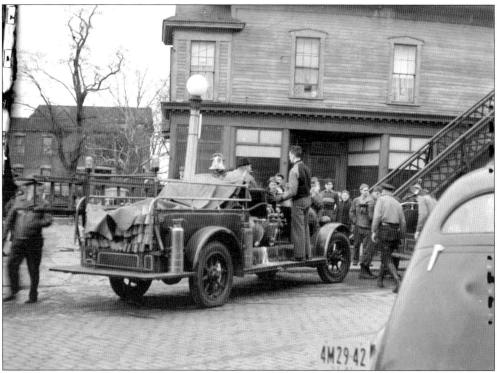

Firefighters answer a call in the early 1940s at the Upton Block on the west side of Union Street, just south of the canal bridge.

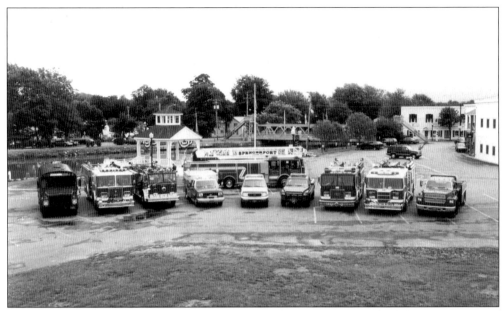

Arrayed in front of the Clyde Carter Memorial Gazebo are the current firefighting apparatus of the Spencerport Fire Department and Ogden-Parma Fire District. This area is also the site of the annual firemen's carnival.

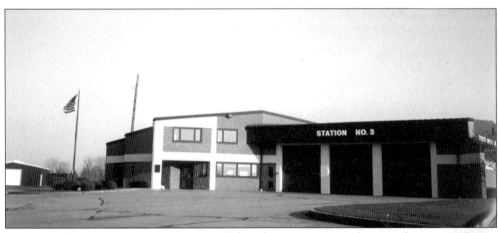

Growth in the Ogden-Parma Fire District led to the construction of a second station at Parma Corners in 1979 and Station No. 3 (pictured here) in 1988. Action is under way to merge the fire district and the village into a single entity for firefighting purposes.

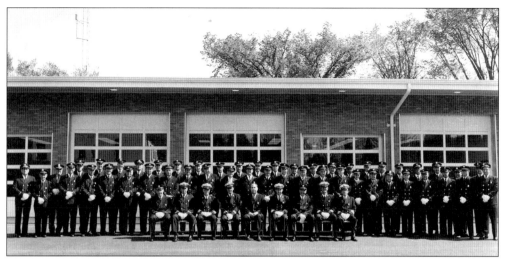

A former auto dealership at the corner of Lyell Avenue and Prospect Street was converted to the new fire headquarters in 1964. This picture, taken in 1964, includes several fire chiefs, all seated in the front row. Among them are Dick McQuilkin (1968–1972), Don Magin (1973–1976), Bob Barton (1965–1967), and Al Zarnstorff (1962–1964). Fifth from the left in the front row is Rev. Don Creech of the White Church.

The King house, located at the corner of Bowery and Canal Streets, was once used as the community jail.

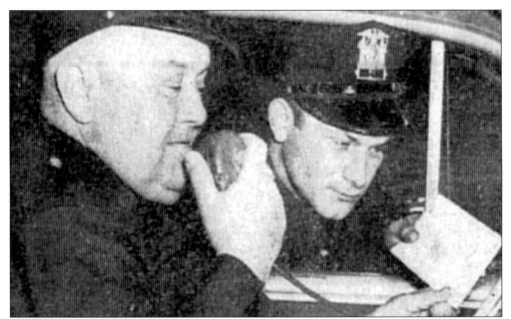

Chief Charles W. Ballard of the Town of Ogden Police Department uses the police car's two-way radio as Off. Joseph Morabito hands him information to be broadcast. This was the entire Ogden force in 1948. Today, Chief Christian Schrank supervises a force of 10. The department has always been based in the town; the village of Spencerport has never had a police force.

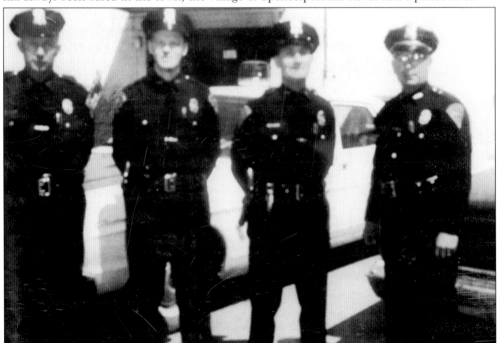

Pictured are Ogden's finest in the 1960s. From left to right are Joe Eeckhout, Lloyd Abee, Tom Pack, and Chief Roy Burley. Chief Burley was highly regarded during his tenure and later served as an elected town justice. Periodically, a movement to eliminate the police department surfaces, but each time, a greater outcry from the citizenry calls for its retention.

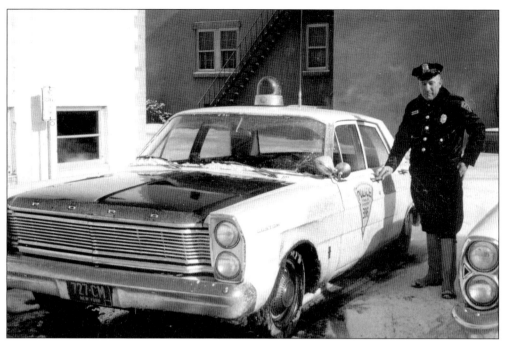

The first police radio car was purchased in 1948 and came equipped with red lights and a siren. Prior to this purchase, officers used their own cars for patrol duty. Joe Eeckhout is pictured here in the late 1960s with a state-of-the-art police cruiser.

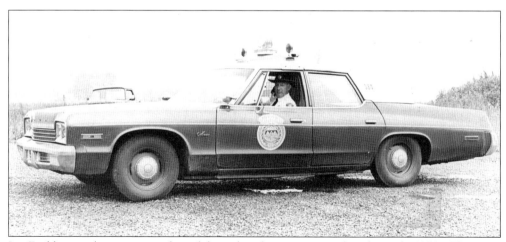

Joe Eeckhout, a longtime member of the police force, is pictured in the early 1970s. The town appointed the first full-time police officer in 1935; prior to this time, police protection was provided by constables stationed throughout the town and village.

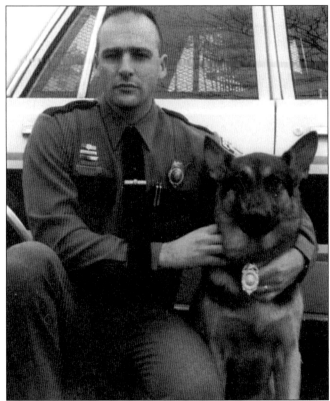

Off. Steve Brown is pictured with now retired police dog Grizzly. The Town of Ogden Police Department maintains a K-9 unit today to track criminals, search buildings for hiding suspects, and look for missing persons.

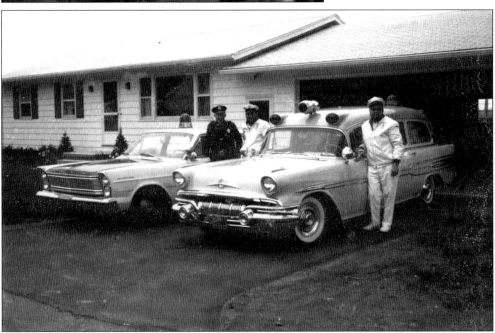

The Spencerport Volunteer Ambulance was organized in 1965 after local officials and members of the fire department recognized the need for local service when a young boy was burned in a gasoline fire. The ambulance headquarters was built on Lyell Avenue in 1966.

Three

CHURCHES
AND SCHOOLS

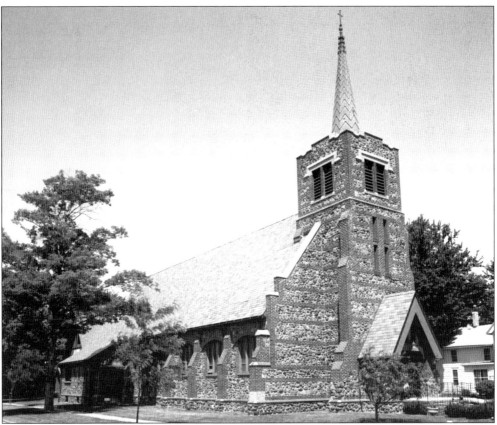

St. John the Evangelist Church, the only Roman Catholic congregation in Ogden, grew out of small worship services held in 1851 by Fr. Michael Welch of Rochester. After moving to several locations, the congregation settled into a church on the corner of Amity and Martha Streets. The first church was blown down during a storm but was rebuilt quickly by the parishioners. The church pictured here was built in 1915. It was constructed of fieldstone and brick brought in by area farmers. The old church was used for a time to show motion pictures, and it is said that several features were shown here before they were shown in Rochester.

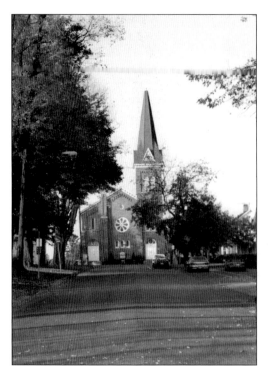

The Spencerport Methodist Church has roots in the town going back to 1807. According to former town historian Earl White, it is said that the first sermon preached west of the Genesee River was delivered where this church now stands. The present building was constructed in 1870–1871 and underwent many renovations throughout the 20th century. In 1909, a two-manual pipe organ was installed, the cost of which was partially defrayed by a donation from philanthropist Andrew Carnegie.

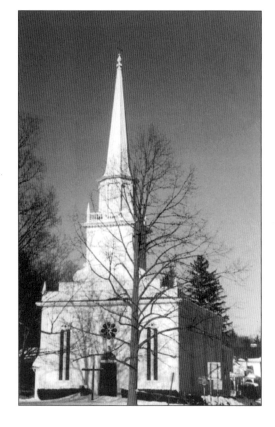

The First Congregational Church of Spencerport was organized primarily by members of the Ogden Center Presbyterian Church in 1850. The first church building was completed in February 1852 and included space for services as well as a basement for Sunday school and lectures. It burned to the ground in November of that same year. The building now known as "the White Church" was completed in November 1853. The church got its nickname because of its white exterior and interior.

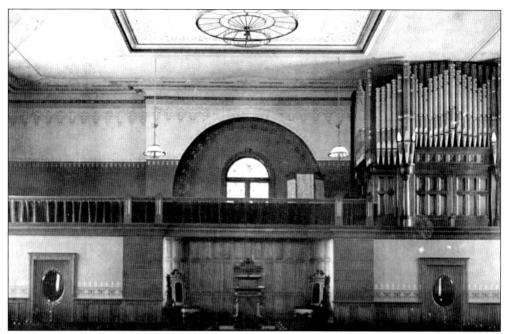

The interior of the White Church in the early 1900s displays the intricate stencilled wall designs and gaslights.

Rev. Charles Fitch was minister at the White Church in 1887.

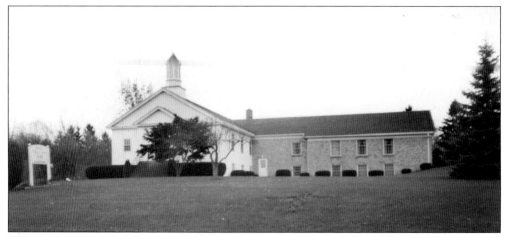

Trinity Lutheran Church was founded in 1958 and opened its doors for the first time on Thanksgiving Day of that year. As more Lutheran families moved to the town after World War II, the need for a local worship space became increasingly important. The church was built on a knoll overlooking Nichols Street in the Heather Acres tract and continues to serve residents today.

The Spencerport Wesleyan Methodist Church split from the North Gates Wesleyan Methodist Church in 1956 due to an increase in church attendance at the Gates facility. The church opened its doors on September 8, 1957, and became a fully organized and official church on May 22, 1960. The construction of this church has an interesting footnote—the floor joists used in construction of the building were the roof rafters from the old sports arena in Rochester's Edgerton Park.

The Ogden Baptist Church was organized at a meeting in the school on South Union Street in 1819 and met in various locations until settling into its current home on Washington Street in 1833. A Sabbath school was established in 1827, and the church continued to support its youth through the Young People's Society of Christian Endeavor, which was organized c. 1840. In 1853, the piano case melodeon that was used to accompany the choir was stolen. Despite the offer of a large reward, it was never recovered. As luck would have it, the organ purchased by the congregation as a replacement was stolen in 1870. Again a reward was offered, but this time it was claimed by a criminal lawyer in Rochester who represented the thief. The organ was retrieved from its hiding place in Buffalo.

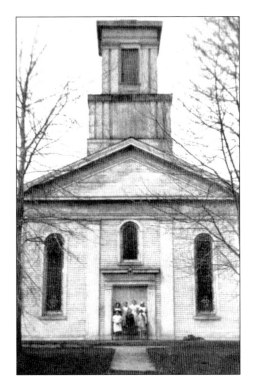

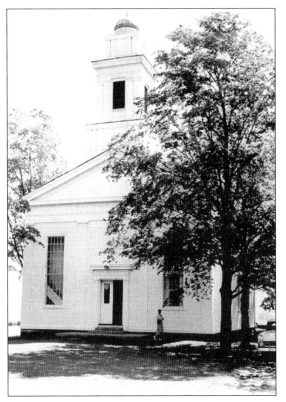

Ogden Presbyterian Church holds the distinction of being the first organized church in Ogden. It was organized before Ogden split from the town of Parma and was originally called the Congregational Church of Parma. It became the Presbyterian Church of Ogden in 1835, when it formed a connection with the Presbytery of Rochester-Geneva. In its early years, the congregation met in various places, including the home of a Mr. Worthington, who owned a tavern located south of the current building in Ogden Center. The present church was constructed in 1824 and has been remodeled several times. The most recent work on the church involved removal of the bell tower in 2000. The bell owned by the church was donated by William Ogden, after whom the town of Ogden is named.

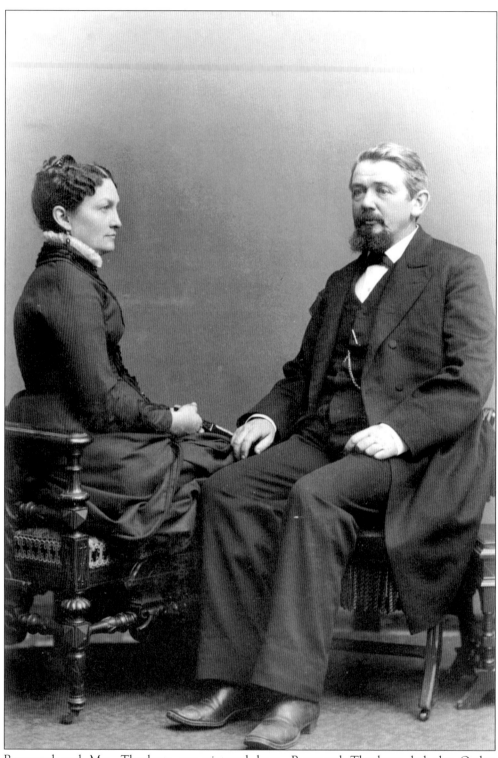

Reverend and Mrs. Thorburn are pictured here. Reverend Thorburn led the Ogden Presbyterian congregation from 1873 to 1890.

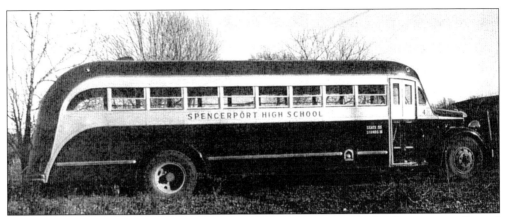

Rusty Sutherland was a bus driver and head of transportation for the Spencerport Central School District from 1941 to 1969. His first bus, No. 4, is pictured here and was used during the 1940s. Sutherland had a special nickname for each student riding his bus, and he could recall it upon seeing the student years later. He had a little dance step he would do upon meeting or leaving you, and one of his favorite expressions was that he was "60/40" when asked how he was doing.

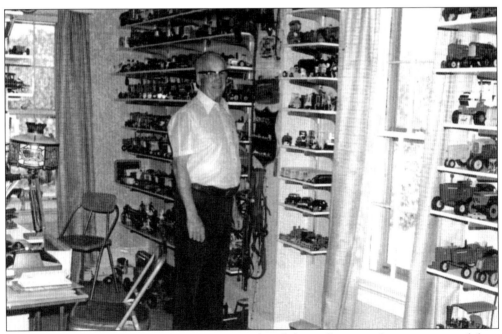

Rusty Sutherland, an avid collector, is pictured with his collection of toy tractors and farm machinery. This collection was valued at well over $70,000 in 1988, when it was auctioned off after his death.

The 1948–1949 class of Ogden District No. 12 poses with teacher Win Fasano. Fasano, a member of the Hoy family, taught for many years in Ogden's schools. Her father, Harold Hoy, fought in World War I and was wounded in 1918. From left to right are the following: (front row) David Miller, two unidentified girls, Clark Parker, Cheryl Cliff, and an unidentified girl; (back row) Ivan Ville, Win Fasano, Darryl Patton, Marilyn Parker, and Warren Patton.

The 1947–1948 first-grade class of Ogden District No. 5 included David Miller (left) and Joyce Pulver (right). One of the first schoolhouses built in the town was constructed on the site of District No. 5 on Union Street just south of Ogden Center.

TEACHER'S CONTRACT

Teacher's copy

This Agreement made the _11th_ day of _May_, one thousand nine hundred and _thirty four_.

By and between the _trustee_

[Insert sole trustee, board of trustees, or board of education]

of district no. _5_ of the town of _Ogden_, county of _Monroe_, party of the first part, and _Josephine Hoy_, residing at _Spencerport_

[Teacher's name]

county of _Monroe_, party of the second part,

Witnesseth: That the said party of the second part covenants and agrees to and with the party of the first part to teach in the public school of said district for the term of _38_ consecutive weeks, except as hereinafter provided, commencing on the _3rd_ day of _September_, 19_34_.

And the said party of the first part covenants and agrees to pay unto the said party of the second part in consideration of such service so to be performed the sum of $_25_ a week, payable at the end of each 30 days during the term of such employment. It is mutually understood that 4 per cent of the amount of each order or warrant issued in payment of the compensation required to be paid hereunder shall be deducted by the party of the first part, as provided by article 43-B of the Education Law relative to the State Teachers Retirement Fund.

And the said party of the second part further covenants and agrees with said party of the first part that the said party of the first part may provide for a vacation or vacations of not more than _3_ weeks in the aggregate during the aforesaid term of employment for which no compensation shall be paid by the said party of the first part and which shall not count as a part of the term of service above referred to.

And the said party of the second part hereby covenants with the said party of the first part that she is duly licensed under the Laws of the State of New York and the rules and regulations of the State Education Department to teach in the public school of said district and is fully competent to perform the services required under this contract.

In witness whereof the parties to these presents have hereunto set their hands the day and year first above written.

Winifred B. Humphrey

Trustees

Josephine M. Hoy

Teacher

A teacher's contract signed by Josephine Hoy in 1934 hired her to teach the children of Ogden for $25 a week. Contracts like this were common in the early years of the 20th century among the district schools scattered around the town. In 1949, the people of the town voted to close the outlying district schools in favor of one centralized school system.

The first school was established in Ogden shortly after the first settlers arrived in the early 1800s. The wife of George Willey conducted classes in her home, which was also used for a time as the town's first library. As more children populated the town, small one-room schoolhouses came into existence in various parts of the town. The class pictured here is one of many that existed in the late 19th and early 20th centuries. The small schoolhouses were closed and centralized into one large school in the late 1940s.

The interior of a one-room school is pictured *c.* 1930.

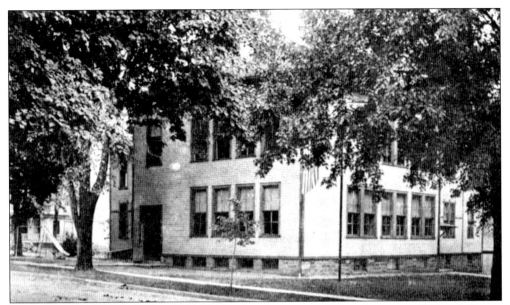

The old Spencerport High School was located at the corner of West Avenue and Church Street. The building was constructed in the late 1870s and, after ceasing to be used as a school in the 1920s, became the home of the Ogden Grange. Today, after considerable alterations by its owner, it is home to offices, retail outlets, and apartments.

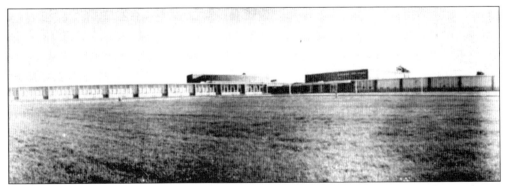

Spencerport High School is pictured in this 1967 photograph. The population boom experienced by the town and village in the 1950s and 1960s required a larger centralized school and led to this building being opened in 1961.

Ada May Cosgrove, arguably the most beloved of all teachers who have ever taught at any of the Spencerport schools, has had her contributions recognized by the naming of the current junior high school in her memory. She began her career with the schools upon her graduation from Brockport Normal School in 1904. Her first 14 years were spent teaching in local one-room schools. From 1918 to 1949, she taught everything from third grade to high school history and mathematics. Her position at retirement was vice principal of the high school. She died in 1978 at age 91. She is pictured below (fourth from the left in the third row) with a ladies' group of which she was a member.

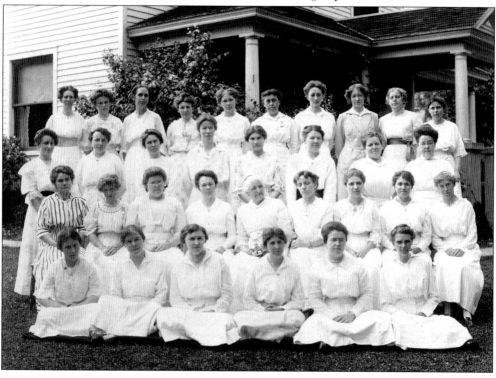

Four

ADAMS BASIN

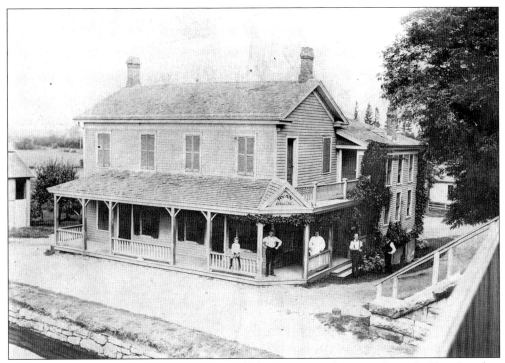

The Ryan House, pictured in 1900, was a well-known inn and tavern along the Erie Canal in the once bustling port of Adams Basin. According to his diary, Marcus Adams of Bloomfield, Ontario County, moved to the area in 1827 just after the opening of the canal. He and his brother Myron ran a store, tavern, and boardinghouse in this building. The house was purchased and restored by Bud and Elsie Nichols in the 1970s and is now known as the Canalside Inn. The inn contains the oldest intact tavern barroom on the Erie Canal today. It was listed on the National Register of Historic Places in 1986.

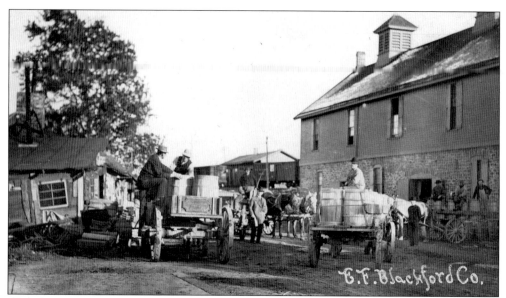

The Blackford Fruit House was one of the larger warehouses in western New York. Thousands of barrels of apples and bushels of potatoes were packed and shipped from this location. In 1904, some produce was shipped by boat, but most went by rail to markets in the East. Cabbage was also stored here in the basement and trimmed out during the winter months. This warehouse was destroyed by fire in 1909.

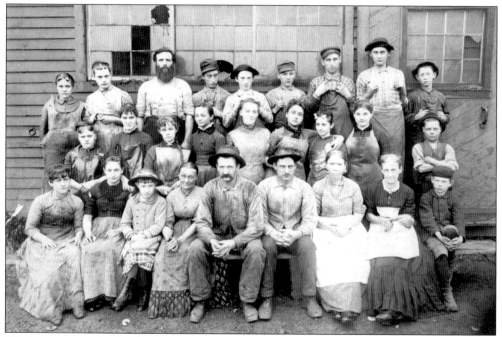

Workers pose at the local cider mill in 1900. The Ward dryhouse and cider mill was located near Cressey Bridge on the north side of the canal. The mill and dryhouse did a big business in making and packing apple mincemeat and drying apples for export. It was also one of the few places women could work in Adams Basin during the early 1900s.

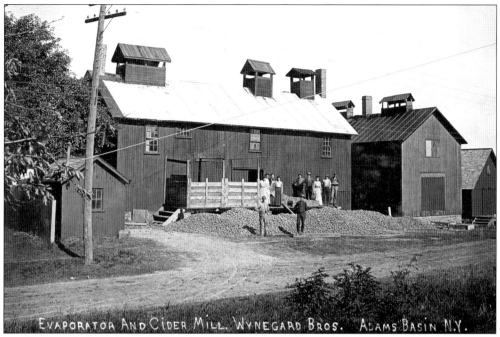

EVAPORATOR AND CIDER MILL. WYNEGARD BROS. ADAMS BASIN N.Y.

Apples are piled on the ground in front of the cider mill in Adams Basin, awaiting their turn in the dryhouse.

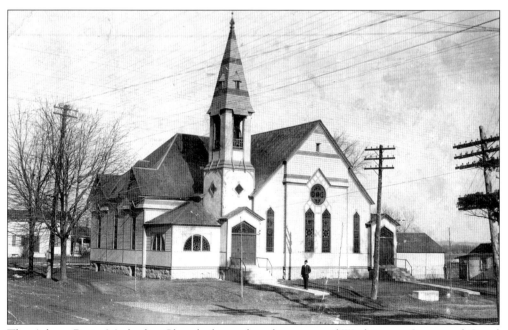

The Adams Basin Methodist Church, located at the corner of Washington Street and Canal Road, was organized in 1828 by Rev. Isaac Fister at the house of Dr. John Webster. Fister came to Adams Basin ill with smallpox and was treated in a makeshift hospital set up on the banks of the canal by Webster. When he recovered, the minister paid his doctor's bill by preaching in the church without pay.

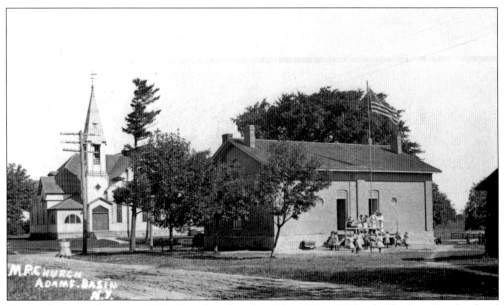

Across the street from the Methodist church is the Adams Basin School. The large brick school was contracted for by Marcus Adams and built in 1846. The school was absorbed into the Brockport Central School District in the 1950s. The building, now known as the Little Red Schoolhouse, houses a preschool program run by the Town of Ogden Recreation Department.

Bessie Davis, a longtime Adams Basin resident, poses in 1910. The view looks south from near Canal Road to the bridge over the Erie Canal.

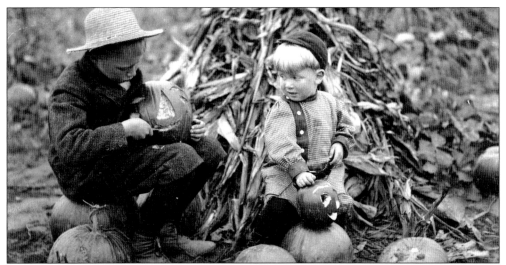
Elwood and Irving Parmele are shown carving jack-o'-lanterns on the family farm in Adams Basin in 1906. Elwood served in World War I as a sergeant first class in the 826th Air Squadron.

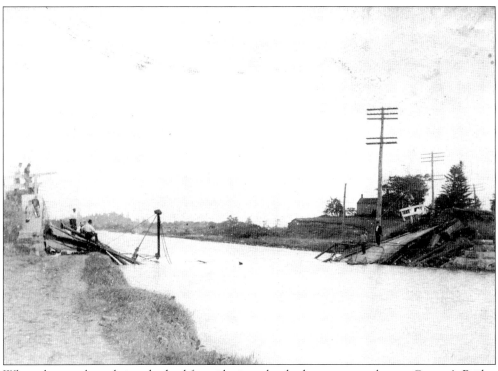
When the canal was being dredged for widening, the dredgers got too close to Cressey's Bridge and weakened the foundation, resulting in the collapse pictured here. Some residents of Adams Basin thought this was done on purpose to save the contractor money. According to Dick Elmes's memoirs, "on a bright, sunny day, just a few minutes after a horse and buggy had crossed the bridge, there was a big crash and the Cressey Bridge went to the bottom of the canal." Traffic on the canal was held up for 10 days while divers got the tangled mess out of the canal.

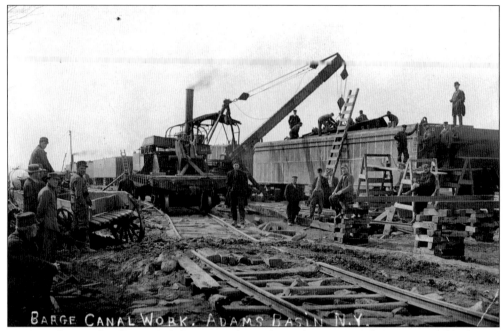

BARGE CANAL WORK, ADAMS BASIN N.Y.

In 1909, the people of New York State voted to enlarge the Erie Canal to accommodate larger, deeper barges. In Adams Basin, a big dredge that was used for digging out the bottom was built on the south bank of the canal. It is said that the noise of the dredge sorely tested the nerves of local residents.

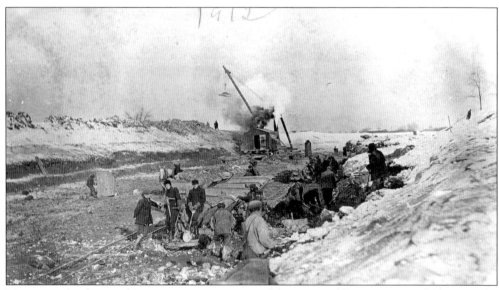

Manpower for the canal construction was imported from central Europe, primarily from Sicily. A long barracks was built in Adams Basin to house the men working there.

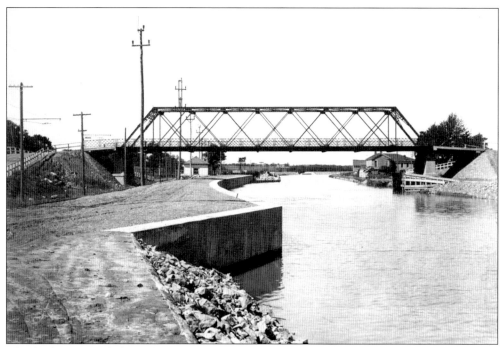

This bridge spanned the widened canal at Adams Basin but was later deemed a poor location. A new lift bridge was built due to the efforts of Frank Blackford and Charles Gallup, who had been elected to the New York State Assembly. That lift bridge is still in use today.

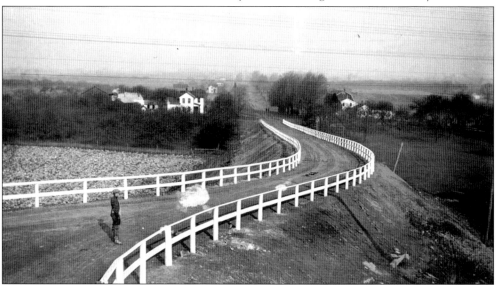

Dick Elmes recounts this story in his memoirs. Walking the line, a state official buying gravel stopped at the Ryan House, looking for Huff's gravel pit. A local man at the tavern was asked to lead the official to the pit. The local man led the buyer east on Canal Road but stopped at Elmes's farm. When asked why he stopped, the man replied, "Because I have to walk the line." Those people who committed a crime either went to jail or were restricted in their travels. In Adams Basin, these restrictions were north to the golf course, east to the Elmes farm, south to Route 31, and west to Gallup Road.

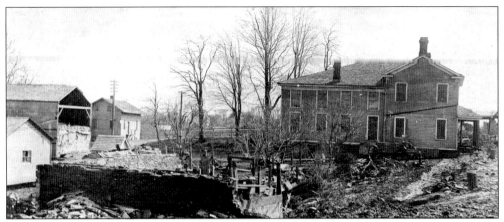

The store-tavern of Marcus Adams, spared from the fire that destroyed a barn on the property, was known as the Ryan House from 1890 to 1915. In 1972, it was purchased by Bud and Elsie Nichols, who found the original barroom virtually intact. Bud, a skilled carpenter and master restorer, converted the structure into the Canalside Inn, an attractive bed-and-breakfast establishment. The inn was sold to Halya Sobkiw in 2002.

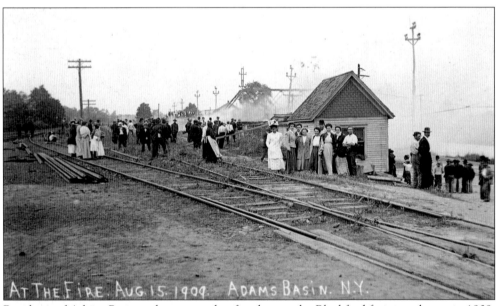

AT THE FIRE. AUG 15. 1909. ADAMS BASIN. N.Y.

Residents of Adams Basin gather to watch a fire destroy the Blackford fruit warehouse in 1909. A fire pumper, drawn by a team of horses, was called from Spencerport. The pumper was worked by handles on each side, operated up and down by firemen. The ruined warehouse was one of several that lined the canal east of Adams Basin. It had been used to store the large crops of fruit and vegetables produced in the area.

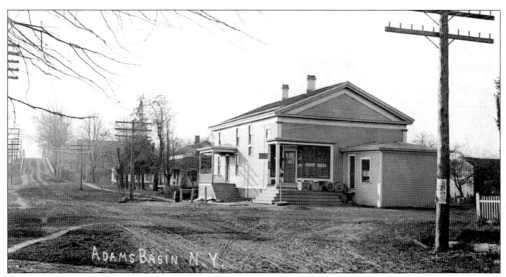

One of the best-known names in Adams Basin history is Ginther. This 1916 photograph shows the Ginther store and post office, at the southwest corner of Washington Street and Canal Road. John Ginther Sr. served as both storekeeper and postmaster for many years and was one of the leaders in the centralization of the Brockport Central School District. One of the schools on the Brockport Central campus is named in his honor. His son, better known as Jack, was also a postmaster and storekeeper. He was ably assisted by his wife, Rita, who since Jack's death, still resides across the street.

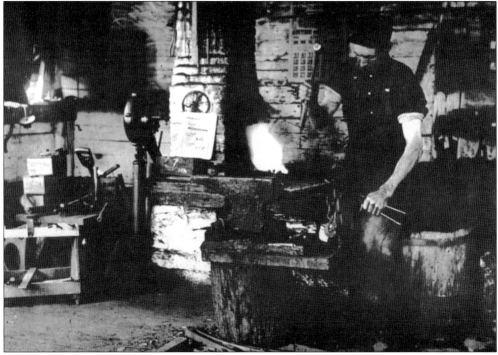

The interior of Mr. Marshall's Blacksmith Shop is shown in this 1906 photograph. Blacksmith establishments were essential in farming towns that relied on animals for transportation and farm work.

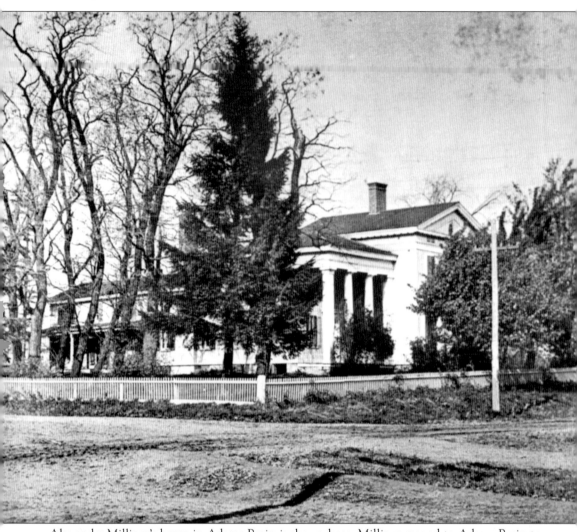

Alexander Milliner's home in Adams Basin is shown here. Milliner moved to Adams Basin to live with his son Joel in the mid-1860s. He held the distinction of having been drummer boy and bodyguard to George Washington during the American Revolution. Milliner died in Adams Basin at the age of 105. The house was torn down, but its significance is remembered with a historical marker on Canal Road just west of Washington Street.

Five

THE VILLAGE
OF SPENCERPORT

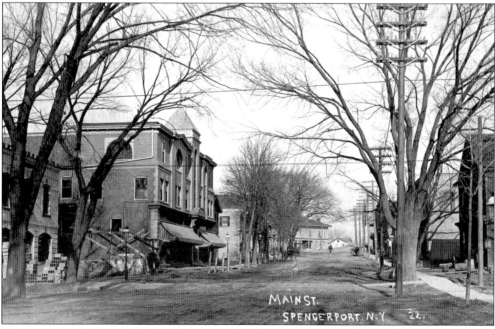

Elm trees are a feature of this 1907 picture of South Union Street. The view looks north toward the Erie Canal. The new village building, soon to be home to the fire department and the Ogden Farmers' Library, is under construction in the left foreground. The Masonic Temple, built in 1905, is visible just north of the construction site. The awnings on the first floor of the temple building shade the front windows of the dry goods store and drugstore. Note the gas lamps used before the days of electric street lamps.

The four houses that still occupy the east side of Union Street, south of Maplewood Avenue and north of Fairfield Cemetery, are shown in this 1920s photograph. Ray and Betty Spencer currently live in the house farthest to the right. Ray is a descendant of Daniel Spencer, the pioneer who first laid out lots in the village that would bear his name.

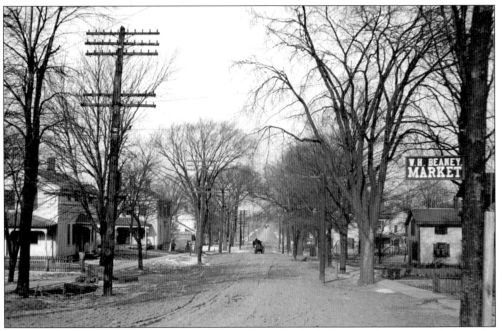

A rutted, muddy North Union Street is shown in this early-1900s view looking north from the Erie Canal. The house to the near left was occupied by the Coyle family, and the next house to the right was the home of the Hoy family.

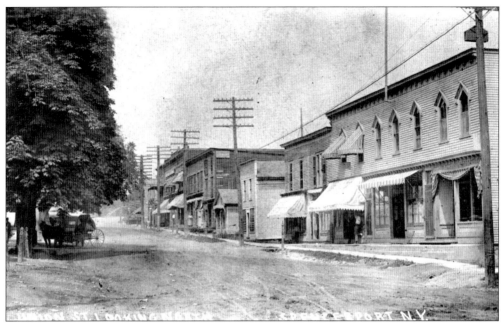

Although Spencerport does not have a Main Street by name, South Union Street is the equivalent. South and North Union Streets are determined by the Erie Canal. This *c.* 1920 view of the east side shows some buildings that no longer exist. Pavement had not yet arrived and horse-drawn vehicles were still a common sight.

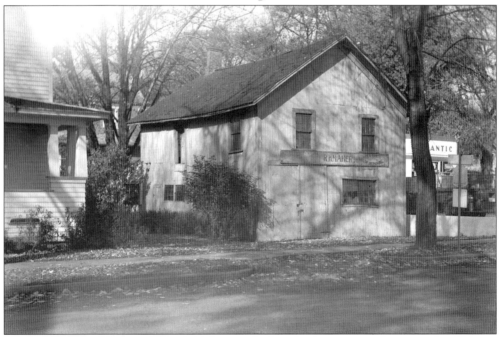

Spencerport's last blacksmith, Dick Maher, worked at this location on the west side of Union Street just south of the service station at the corner of West Avenue. The Atlantic Oil Company station is visible to the right of the blacksmith shop. All three buildings are gone today.

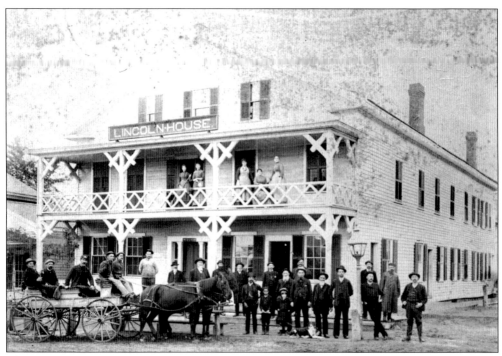

The Lincoln House was Spencerport's hotel in the late 1800s. It was located on the west side of Union Street, north of Amity Street.

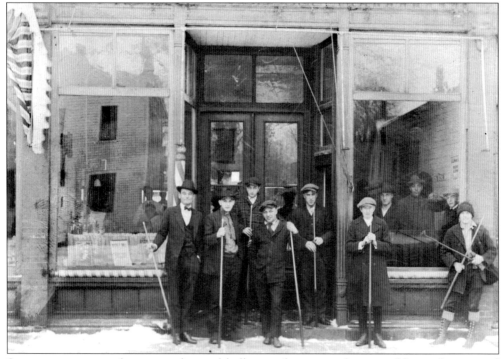

Spencerport apparently supported a pool hall, or at least several men and boys who enjoyed displaying their cues, as seen in this *c.* 1920 photograph.

The Bank of Spencerport building, located on the west side of Union Street, is currently occupied by the Family Hardware store. The bank was founded in 1907, and the building shown here was erected in 1925. Sad to say, it failed in the 1930s along with many others. The building continued to function as a bank (the Genesee Valley Trust Company and the Marine Midland) until the 1960s. The facade of the building, including the pillars, were transported from a former bank building on State Street in Rochester to Spencerport in 1925.

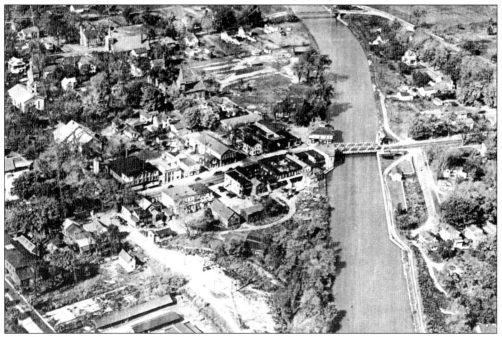

The Erie Canal dominates this 1938 aerial photograph of downtown Spencerport. The basic pattern of current-day Spencerport was present in 1938, but the area in the left foreground (then dominated by the elongated lumber sheds of McCabe's Lumber Company) is now the Spencerport Village Plaza.

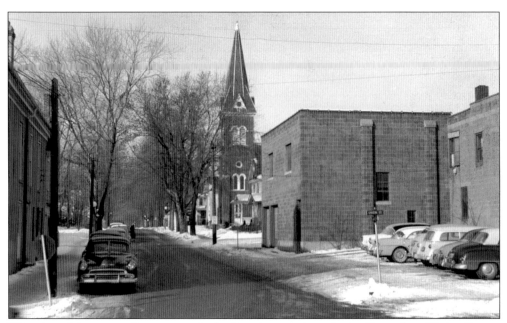

This view of downtown Spencerport looks directly west along Amity Street from Union Street. The Spencerport Methodist Church is clearly visible, as are the globe streetlights and 1950s automobiles. The building in the foreground was still part of the Matheos Brothers Ice Cream block. It was later used as the post office. Lester Kincaid, postmaster from 1934 to 1964, supervised moving the post office to this site during his term.

Lester Merz is shown sweeping leaves from his driveway. His home was on the north side of Amity Street just east of the Methodist church. He served as mayor of Spencerport from the late 1940s until the late 1960s. He was an owner of Walker Brothers Funeral Home.

This house on the north side of Canal Road, west of the Martha Street Bridge and east of Trimmer Road, was once a tavern on the Erie Canal. It is a now a private residence.

This familiar Spencerport building, originally the Masonic Temple, was constructed in 1905 and is still owned by the Masons. A disastrous fire gutted the building in 1911, but even more serious damage was prevented by the action of Chief W.J. Ireland and his firefighters, who were aided by the newly installed municipal water system. The businesses occupying the ground floor in this 1983 photograph were preceded by Austin's Drug Store, Salitan's Department Store, and others.

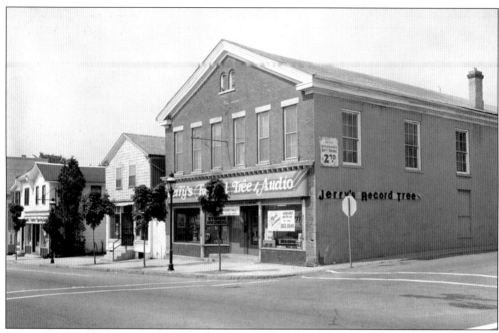

This 1983 view, looking southwest at the intersection of Amity and Union Streets, shows the Odd Fellows Hall, with Jerry's Record Tree occupying the ground floor and a barbershop to the south. The hall was destroyed by fire in the mid-1990s and is now the site of the post office parking lot. The International Order of Odd Fellows was a thriving organization in the era of fraternal societies. The building was originally a church but was converted by the Odd Fellows to a meeting room and dining facility on the second floor, with rental space for businesses on the first floor. Saturday night dances were a favorite of locals during the 1920s and 1930s.

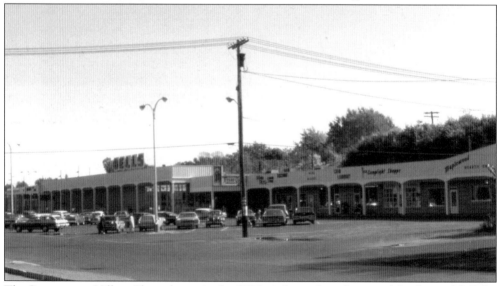

The Spencerport Village Plaza, shown in the 1980s, is located on the site of the former McCabe lumberyard east of Union Street off Slayton Avenue. The plaza was originally developed by the Parker family, who built many homes in the village and town from the late 1940s through the early 1970s.

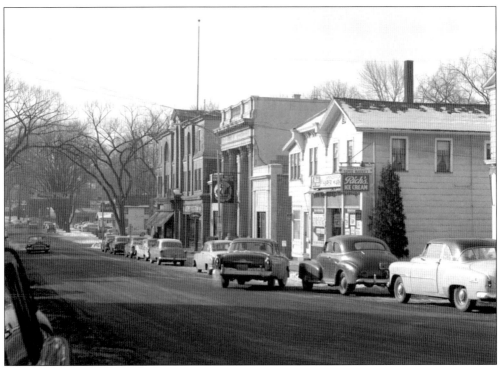

This view of the west side of South Union Street in the 1950s shows the Rowley Chevrolet dealership, the Masonic Temple, Genesee Valley Union Trust, and the Spencerport Supermarket.

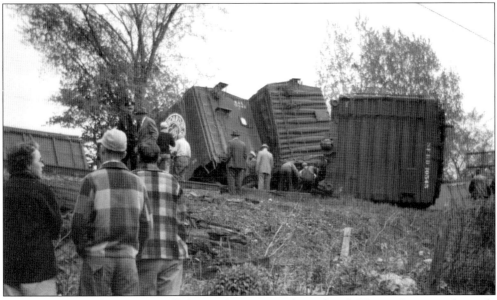

Seventeen railroad cars came off the tracks running above South Union Street in the early 1950s. The cars tumbled down the embankment and fell into the backyard of the Moore homestead at 200 South Union Street. A car fell into the south side of the garage, and a coupling landed at the bottom of the Moores' back wall.

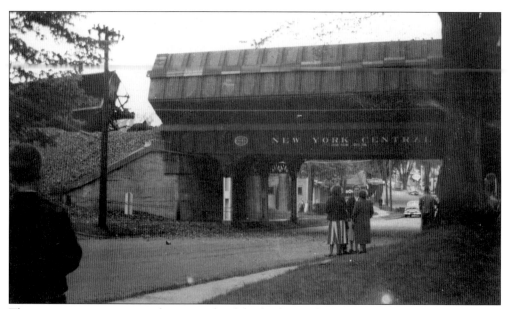

The engine came to rest on the west side of the bridge, and one coal car ended up hanging off the south side of the bridge

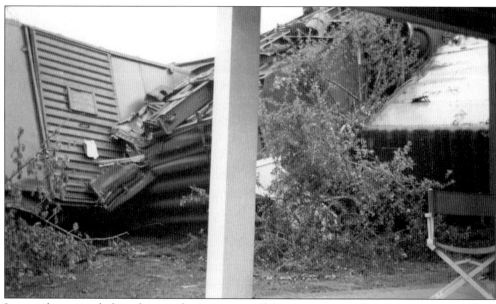

It was determined that the accident was caused by too many spikes being removed from the tracks.

Six

TOWN PUMP AND SOUTH OGDEN

Pictured is the famous pump that gave Town Pump its name. Located at the intersection of Whittier Road and Washington Street (formerly known as Churchville-Adams Basin Road), the pump was in service from the mid-19th century until the 1920s. In the background is the Ogden District No. 7 school that served the community from 1819 to 1953.

Town Pump had not only a school, a store, and a post office but also a blacksmith shop. Bert Smith, son of blacksmith Ed Smith, is shown in this early-1900s photograph in front of his father's shop. The shop was located at the southeast corner of Whittier Road and Washington Street.

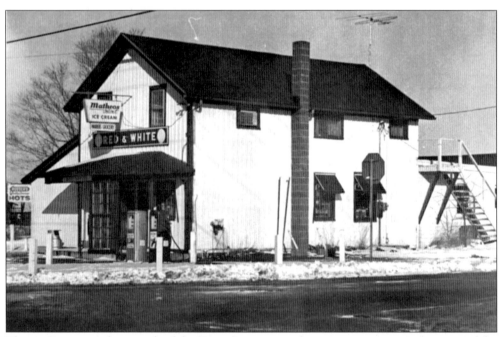

This 1950s winter photograph of the Town Pump general store captures in signage some of the well-known names of the era. Red & White stores were common, as were Russer Hots and Matheos Ice Cream. The store was run by various families, including the Meyers, Curtises, Maurers, Reixingers, Greenblatts, Garners, and Maloneys. The store also doubled as a post office from c. 1880 until 1903. Old maps still note "Ogden P.O." at this location.

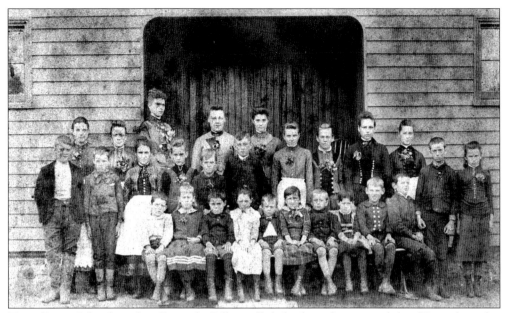

Town Pump School teacher Gertrude Gillman (left, back row) poses with her 27 pupils in this pre-1920 photograph. The building was constructed in 1888 at a cost of $1,200. Early school records reveal that each family sending children to the school had to supply one cord of wood to heat the building in the winter. The Town Pump school, along with the other 13 one-room districts in Ogden, was centralized in the early 1950s. Town Pump became part of the Churchville-Chili Central School District. School reunions were a regular event for Town Pump District No. 7 graduates through the 1930s.

The Town Pump School is shown today as remodeled by Jim and Karen Godshall. The building is still located at the corner of Whittier Road and Washington Street.

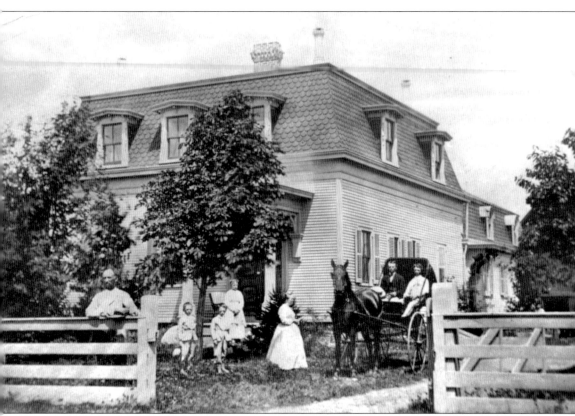

Members of the Bannister family are pictured *c.* 1875 in front of their home on the north side of Dewey Street near McIntosh Road in the southwest corner of Ogden. The house still stands at the same location. Twins Willis and Lewis Bannister are standing beneath the tree.

Willis and Lewis Bannister are pictured on their 21st birthday in 1885. It is said that the boys were the first identical twins born in Ogden.

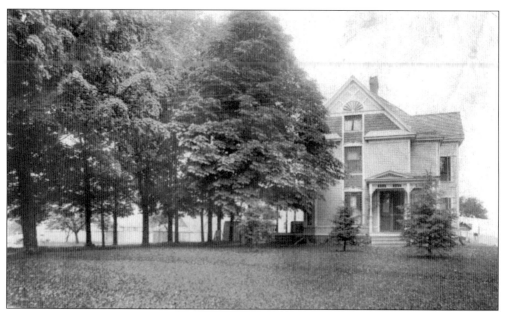

The True homestead was built in 1889 by descendants of pioneer settlers who came to Ogden from Plainfield, New Hampshire, in 1816. Four generations of Trues operated the dairy farm on the west side of Washington Street, north of Chambers Street.

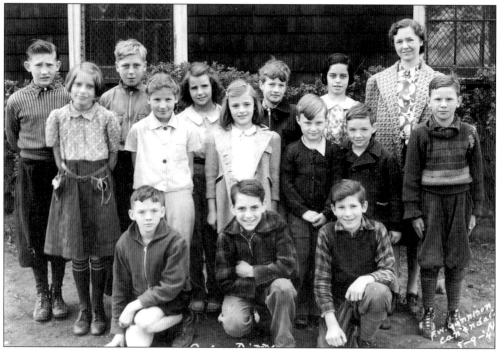

Lucy (Maher) O'Brien is pictured with her students at Ogden District No. 6 in 1941. As in other one-room schools in the area, all eight grades were guided through reading, writing, and arithmetic, along with many other subjects and activities, by a single teacher. O'Brien taught at the school until it was centralized into the Churchville-Chili School District in the late 1940s.

Dr. Vito O. Laglia practiced medicine in South Ogden from 1949 to 1985. When he began his family practice out of his Westside Drive home, an office call cost $1, a house call $2, and a delivery $25.

Laglia and his wife, Catherine, moved into 2020 Westside Drive (then Ogden-Chili Townline Road) in 1948. He began his medical practice in 1949 by treating students in a basement clinic at Roberts Wesleyan College. His practice grew quickly, as did his family of seven children, requiring an addition to the Laglia's Westside Drive home.

This old farmhouse, located on Westside Drive, dates back nearly 200 years—the year 1814 is inscribed on a basement timber—and has been owned by members of the Beaman family for three generations. It was purchased in 1906 by Charles Beaman and features thick fieldstone walls, a brick-lined cistern, and a hand-dug well within the basement area. Linda (Beaman) Dougherty was born in this home and has the distinction of being Dr. Vito Laglia's first home delivery in Ogden.

A farmer and builder, Allan Beaman worked with his uncles Frank and Roy Beaman, who built many of the large barns and Dutch Colonial homes still standing in Gates, Chili, and Ogden. Ineligible for the draft in World War II because of a baseball injury to his throat, he worked at Sampson Naval Base, building enormous drill halls. After the war, he started building houses on his 67-acre farm on Westside Drive. Many of these homes were bought by returning veterans. In addition to building hundreds of structures in the Chili and Ogden area, his company also built the Petherbridge Auto building in Churchville. Allandale and Beaman Roads are named for him.

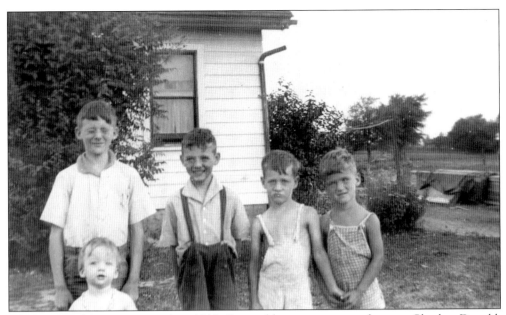

The Beaman boys are pictured in 1942. From oldest to youngest, they are Charles, Donald, Kenneth, Larry, and John Beaman. The house in the background was built in 1931 with a second loan from Allan Beaman's uncle. The first loan was deposited in the Bank of Spencerport but was lost when the bank failed in the 1930s.

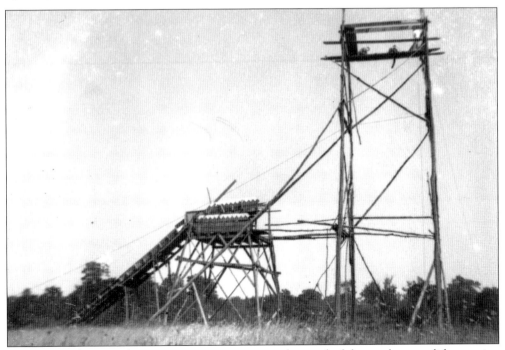

The Beaman boys, in their teenage years, constructed several of these toboggan slides ranging in height from 20 to 60 feet. Many school friends still recall the excitement of a run down these slides and have fond memories of the social gatherings that took place here. The activity slowed and finally ended when Larry Beaman fell from the top of this tower and was seriously injured.

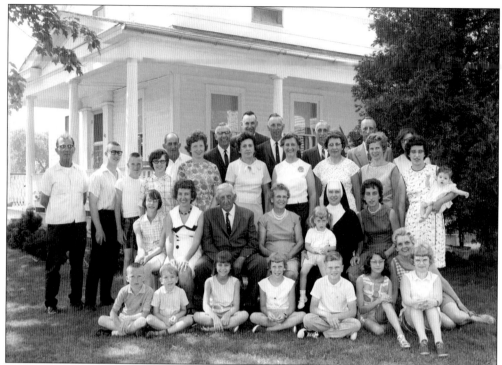

The Statt family is pictured in 1966. Statts have been landowners in South Ogden for generations, and Statt Road is named for the family. Ray Statt (center, back row) served as Ogden highway superintendent in the 1960s and 1970s.

The Statt family homestead is shown in 1981.

The Bischopings, a large farm family from the corner of Gillett and Whittier Roads, are pictured here. Many farm families were large to fill the need for many hands to do the extensive manual labor required by farm life. Frank and Anna (Gurgel) Bischoping are surrounded by 12 of their 13 children. From oldest to youngest, they are Rita, Edward, Arlene, Theresa, Anna, Frank, George, Edna, Joan and Jerome (twins), Joe, and Rosemary Bischoping. Not pictured is Robert Bischoping, who was then serving in the army. Eleven children are still living, many of them in the Ogden area. Family picnics today bring together as many as 210 family members.

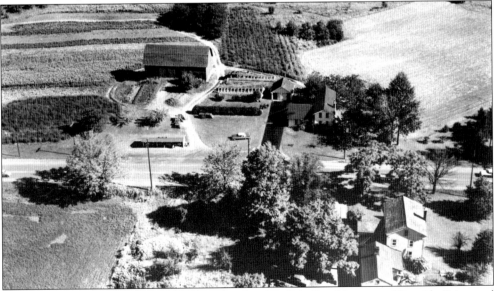

Schur Brothers Farm Market, on the south side of Buffalo Road between Westside Drive and Stony Point Road, opened in 1936 and closed in 1972. Francis and Bernard Schur provided top-quality fruits and vegetables to families and markets all over the area.

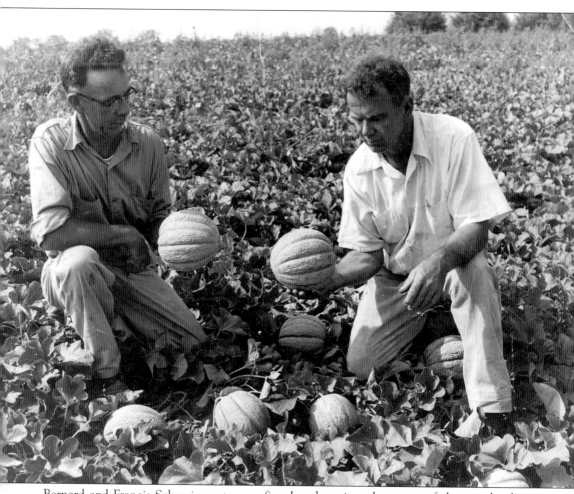

Bernard and Francis Schur inspect some fine Irondequoit melons, one of the popular fruits grown on their farm.

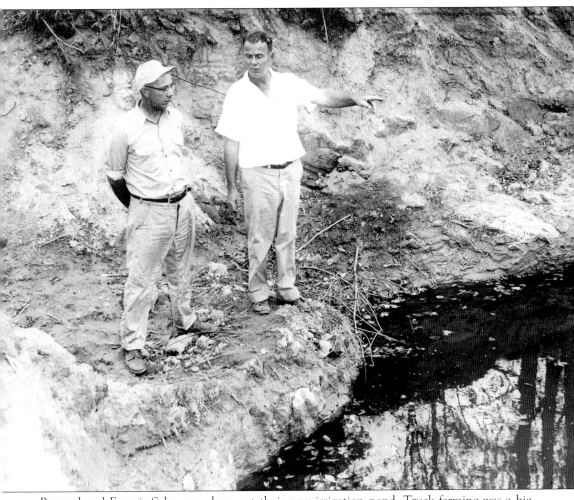

Bernard and Francis Schur are shown at their new irrigation pond. Truck farming was a big industry in Ogden, and irrigation was important to forestall crop damage or failure in times of drought. The cost of such a system is justified by customer satisfaction in the produce.

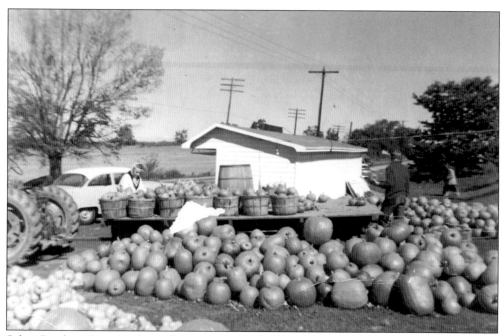

Schur Brothers Farm Market is shown ready for Halloween.

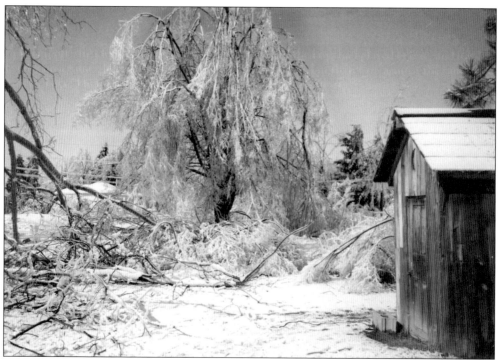

A severe ice storm in 1991 devastated trees all over Ogden, as illustrated in this scene at the homestead on the corner of Westside Drive and Beaman Road.

Seven
BUSINESS AND INDUSTRY

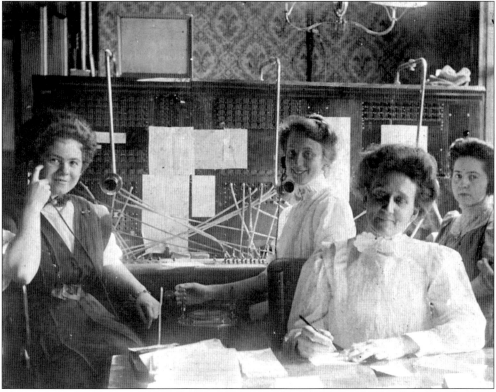

These Ogden Telephone Company operators are, from left to right, Mabel Whittle, May Sprong, Myrna Cox, and Clara Hewitt. The photograph was taken in 1910 at the company's headquarters in the Upton Block on South Union Street. Operators interacted with customers using the familiar "Number, please," and calls could not be completed without their assistance. The Ogden Telephone Company, formed early in the 1900s, provided local phone service to more than 200 people. Early on, out-of-town calls, including those to nearby villages such as Churchville and Hilton, were very limited. As the company grew, however, so did its range of services.

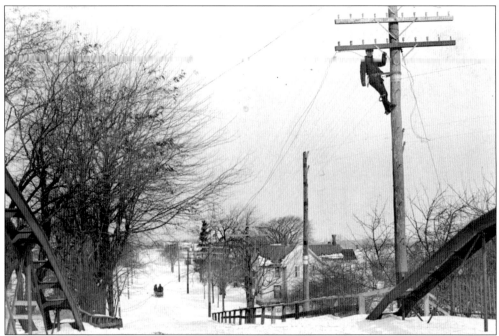

An Ogden Telephone Company employee is shown working on a pole in Adams Basin c. 1900. The wintry scene is further enhanced by a sleigh pulled by two horses heading north on Washington Street. The company was purchased by Donald Davison in 1942. It grew and consolidated with the Hilton Telephone Company in 1957, providing fully automated local dialing exchanges. Maxine Davison continued to run the company after Donald's death but eventually sold to Citizens Communications in the 1990s.

Frank Webster's store, shown here c. 1900, was located on the east side of Union Street. The photograph is notable for the reflection of buildings on the west side of Union Street, including the post office of the period, in the windows of Webster's store.

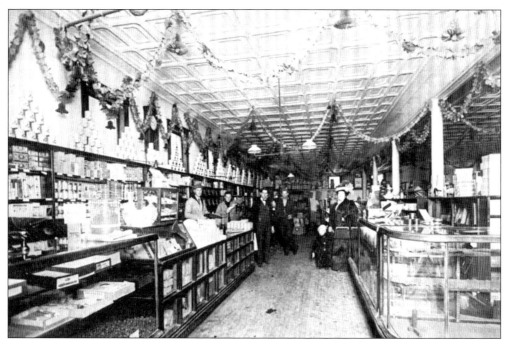

Residents gather in the Cole Freeman & Company store c. 1916. The store was located on the south side of the Masonic Temple. From left to right are Raymond Flagg, Charlie Flagg, Leonard Trimmer, Will Hubble, and ? Hubble.

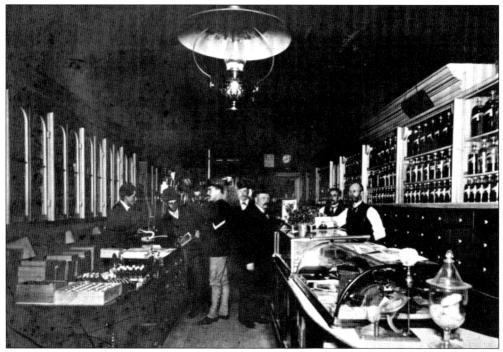

Men gather in Milliner's Drug Store in 1898 to discuss the Spanish-American War. From left to right are Dan Wolfram, Bill Truesdale (in uniform), Jack Stevens, Ed Arnold (at counter), Bert Smith, and Dr. W.S. Milliner (behind the counter).

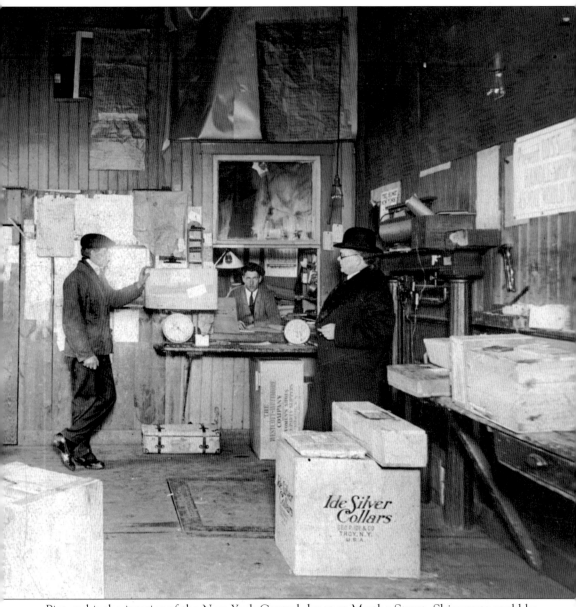

Pictured is the interior of the New York Central depot at Martha Street. Shipments could be made to any point across the country on the Central, which publicized its high-speed New York–Chicago route. The Falls Branch ran through Spencerport.

Hank Allen is shown with his team of horses at the corner of Slayton Avenue and South Union Street in the 1930s. Allen delivered coal in the employ of W.B. Moore and Company by riding on a wagon pulled by the team. Moore's office was in the building currently used as a veterinarian's office on Slayton Avenue just off Union Street. In the background of this photograph is the Lissow Hardware Store, on the site currently occupied by the HSBC bank.

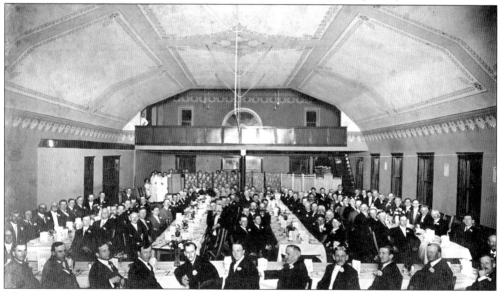

This 1910 photograph of the Spencerport Chamber of Commerce shows the level of commerce in Spencerport at the time. The Erie Canal and improved rail transportation created a lucrative climate for businesses such as milling, retail stores, farming, and lumber. Spencerport hosted a wide variety of businesses during the 19th and 20th centuries, including a cider and vinegar works, fruit dryers, lumberyards, coal yards, a popcorn factory, and a fireworks factory. The current Spencerport Area Chamber of Commerce continues to encourage and promote new business in the town and village.

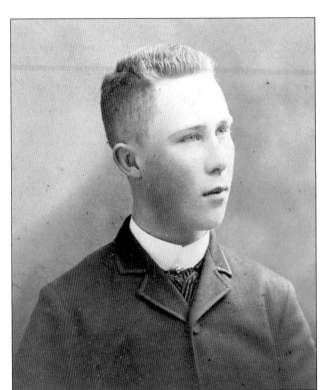

George "Pete" Webster, Frank Webster's nephew, ran a livery stable located at the end of Martha Street.

Mr. Whipple kept a barbershop on Union Street in the 1880s.

Miss Ashford kept a millinery shop on Union Street where the Masonic Temple is now located. The Ashford family lived on the west side of Union Street, three houses south of the railroad crossing.

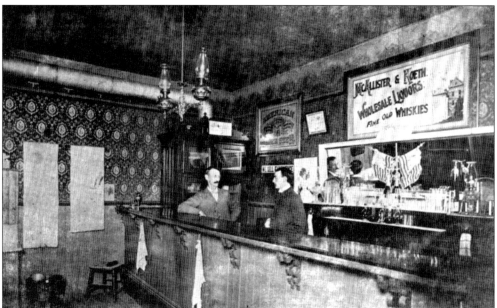

Charles and Elmer Smith tend the bar at the Spencerport Inn in this early photograph. The town and village residents voted to become dry communities prior to the passage of the Volstead Act in 1918, so establishments such as this one found their business gradually dwindling away.

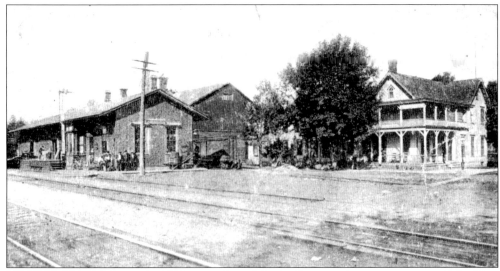

Looking northwest, this early-1900s view shows Martha Street at the intersection with the New York Central Railroad. The building to the left is the railroad station, which is a day-care facility today. The next building is one of the many warehouses that lined both sides of the railroad tracks from east of Martha Street to Clark Street. The building on the right with the porches on two levels is the Spencerport Inn, which served as a community meeting place into the early 1970s. Service clubs and other organizations used the inn for meetings and dinners while a regular bar trade flourished. The inn was originally the Upton House, built in 1853.

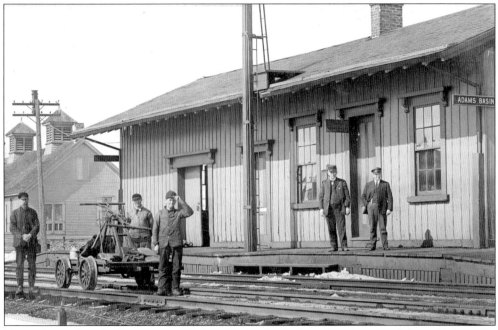

Not to be outdone by Spencerport, Adams Basin also had a railroad station. The vehicle at the left is a hand car. Operated by two men raising and lowering the metal handles, it was used for track inspection and maintenance. Both Adams Basin and Spencerport shipped large quantities of fruits and vegetables grown on area farms, especially apples and other fruit from the Ridge Road area, and potatoes and cabbage from areas to the south.

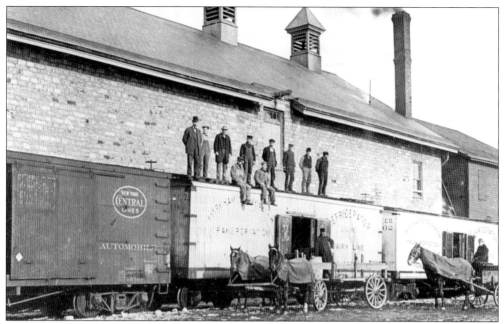

Pictured is one of the large masonry warehouses located between Martha and Clark Streets, along the New York Central Railroad. In this pre-1920 photograph, the word *automobile* is visible on the car to the left, but horses still did much of the work, as evidenced by the wagons to the right. Although it is uncertain whether he is pictured here, John Talbott's name is written on this photograph as an operator of a general produce business. Talbott had a farm south of the railroad. It is the current location of a housing tract developed in the 1970s and locally referred to as the "Domus tract."

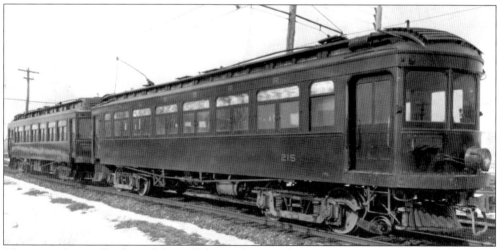

The interurban trolley line of the Buffalo, Lockport and Rochester ran parallel to the New York Central tracks. The Buffalo, Lockport and Rochester ran electric cars like the pair pictured here. The Central ran on an elevated bed, which still remains in Spencerport, but the trolley line ran across Union Street at West Avenue. The old rails, covered over by blacktop, used to reappear whenever West Avenue was in need of repair. The trolley was a commuter line that lasted until the popularity of the automobile and the construction of better highways put it out of business.

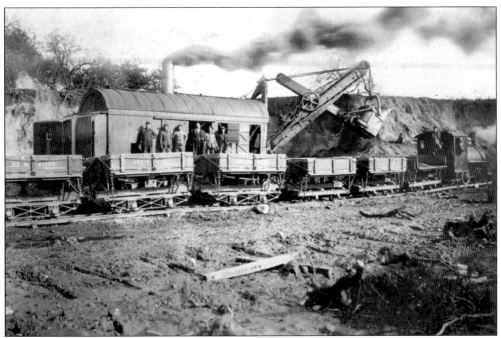

A steam shovel is pictured loading dump cars during the construction of the Buffalo, Lockport and Rochester interurban railroad c. 1906. The location is west of Spencerport and east of Trimmer Road in an area long referred to as "the cut."

This view, looking east from Washington Street in Adams Basin, illustrates the four types of travel used in the early 1900s. Starting on the far right are two boxcars of the New York Central Railroad; the tracks of the Buffalo, Lockport and Rochester trolley line; a gravel road (now paved and named Lyell Street); and the warehouses along the Erie Canal.

Workmen from a section gang repair a switch in the yard near the south end of Clark Street in Spencerport in the early 1900s. Note the warehouse to the right, the caboose on the tracks, and the cut in the distance.

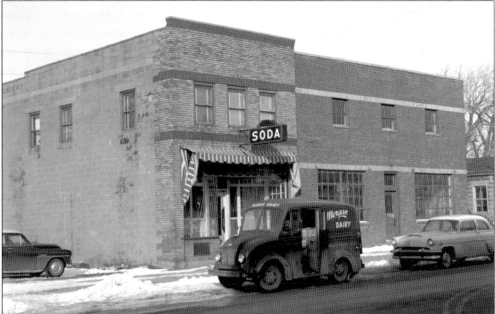

Two well-known names in the history of Ogden and Spencerport are portrayed in this 1950s view of the west side of South Union Street, north of Amity Street. Morgan Dairy was based on the south side of Whittier Road west of Union Street, where members of the Morgan family still farm today. The dairy business, including door-to-door delivery of bottled milk, lasted into the 1970s. Joseph E. Morgan and Raymond Morgan were Ogden supervisors in the 1930s and 1940s. Matheos Velvet Ice Cream was dispensed in the building with the "soda" sign. James and Chris Matheos emigrated from Greece before 1920 and established a candy business, which they later expanded to include ice cream. A fleet of refrigerated trucks distributed ice-cream products within an 80-mile radius of Spencerport, and the shop in Spencerport became a favorite weekend destination for Rochester families out for a Sunday drive.

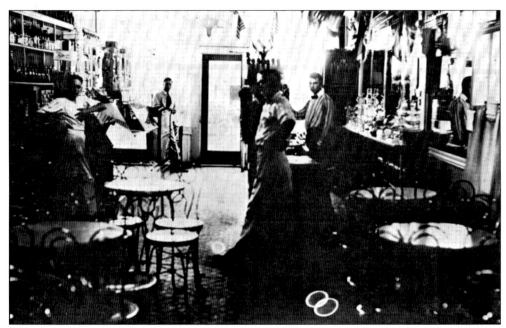

Relaxing at the Matheos ice-cream parlor are, from left to right, Chris Matheos, Lester Merz, Jim Matheos, and Vin Ladd.

David Walker and son John pose in front of Walker Brothers when the funeral parlor was located on the east side of Union Street.

Fred Walker not only served as the undertaker for the village and town but was also fire chief for a time.

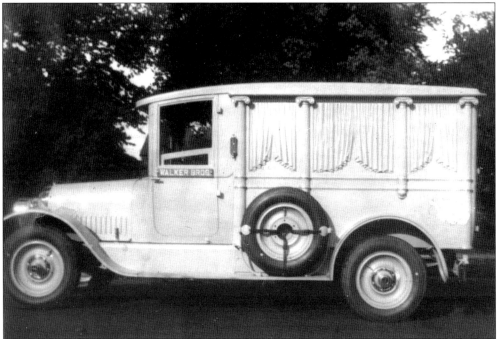

Fred Walker constructed the first Walker Brothers hearse by hand, without using screws or nails, c. 1915. It was in service from 1916 to 1924.

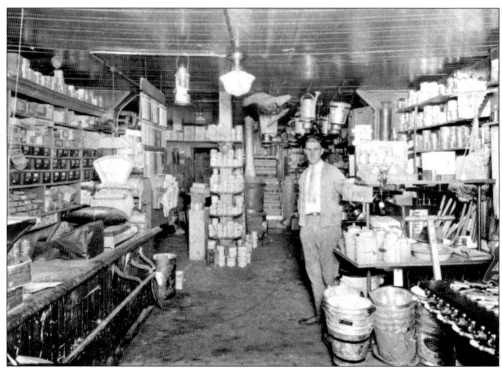

F.W. Spencer's Hardware Store supplied residents with tools, supplies, and good conversation for many years.

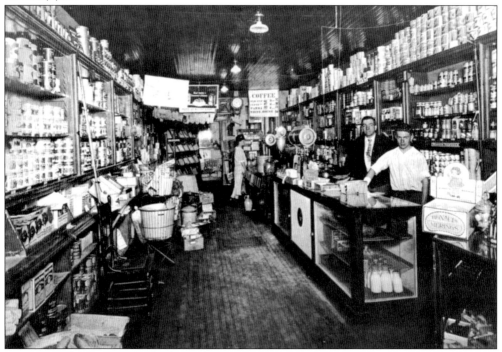

A customer browses at the back of Shafer's Grocery Store, a bustling place where residents could buy dry goods, milk, produce, and other household items.

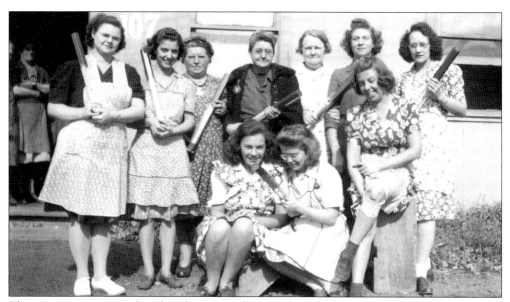

These women were employed at the Antonelli manufacturing plant, located on the south side of Big Ridge Road near the current location of the Wemoco BOCES II buildings. Before and after World War II, the plant manufactured fireworks for retail sale. During the war, Antonelli was awarded a contract to manufacture hand grenades and other explosive devices for the military.

Joseph Kelleher (right), manager of the Genesee Valley Trust bank and secretary of the Spencerport Businessmen's Association, presents a membership certificate to Herb Brueckner, treasurer. The Businessmen's Association has evolved into the Spencerport Area Chamber of Commerce, and Genesee Valley Trust is now HSBC bank. Herb Brueckner was the well-known proprietor of the bar now known as Diehl's Erie Canal. Legend has it that traffic would be blocked on Union Street as soon as the fire whistle sounded so that the firemen could sprint across the street from Brueckner's to the firehouse at the corner of West Avenue and Union Street. Herb's wife, Pat, was the editor of the *Spencerport Star* newspaper for many years.

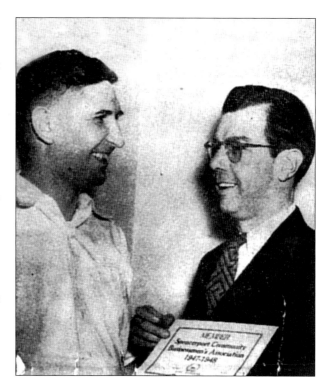

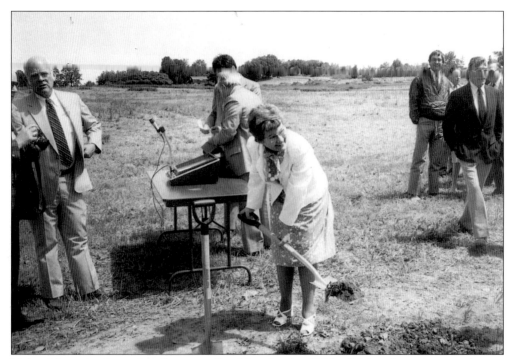

Helen Moore is pictured at the groundbreaking for the Caldwell Manufacturing complex on Manitou Road in the mid-1980s. The Caldwell construction led the way for the development of additional businesses in this area.

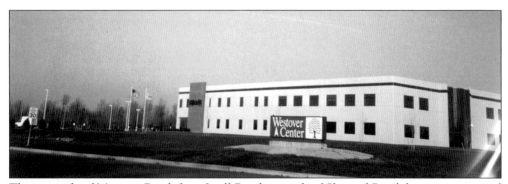

The west side of Manitou Road, from Lyell Road to south of Shepard Road, has seen increased industrial development since the Caldwell project in 1985. The Westover Center on Paragon Drive has grown considerably, with the most recent addition being the Hover-Davis building (shown here) in 2000. The influence of the former Kodak Elmgrove plant (now known as Rochester Technology Park), located across Manitou Road in the town of Gates, and the access now available from Route 531 have given impetus to this type of job-creating development.

Eight
FARMING AND
COMMUNITY

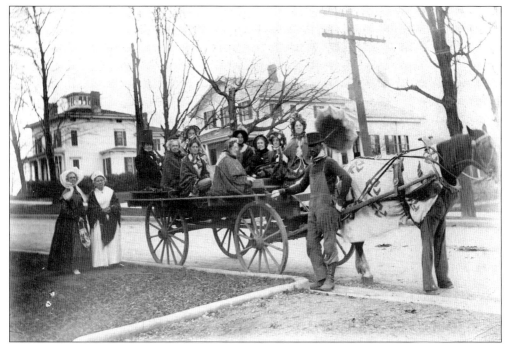

Several ladies of the village formed a social and sewing club called the Needleites *c.* 1900. They would meet once a month and dress in fashions of an older period. Some of the ladies are shown seated in a horse-drawn wagon. The view looks west toward houses on South Union Street.

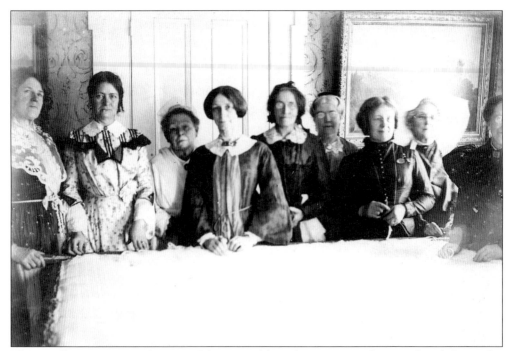

The Needleites are pictured at one of their monthly quilting parties. They are, from left to right, unidentified, Mrs. George Benton, Mrs. Worthy Baker, Mrs. Lewis Slayton, Mrs. Edward Nichols, Mrs. Edwin Austin, Mrs. Ira Lapp, unidentified, and Harriet Moore.

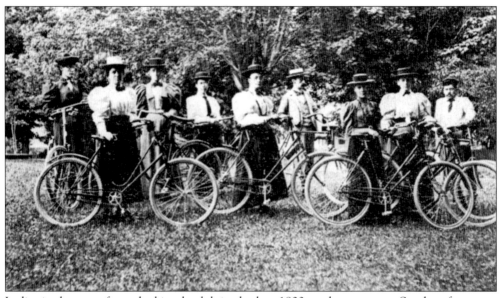

Ladies in the town formed a bicycle club in the late 1800s and spent many Sunday afternoons cycling through the countryside.

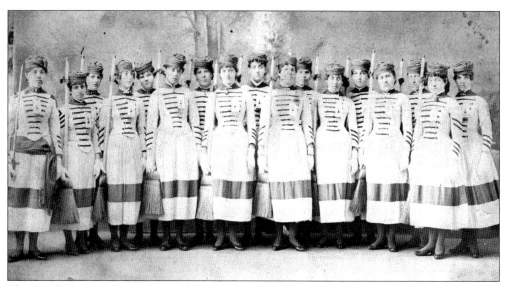

The Civil War was the greatest conflict in American history, with more than two million men serving in the Union army. After the war, a huge veterans organization, the Grand Army of the Republic, played a major role in advocating for the veterans and serving as a social organization. Female relatives of Grand Army of the Republic members formed their own groups, including the women in this 1883 photograph, who were members of Spencerport's Broom Brigade. The brigade would march in parades and perform synchronized drills using brooms instead of guns.

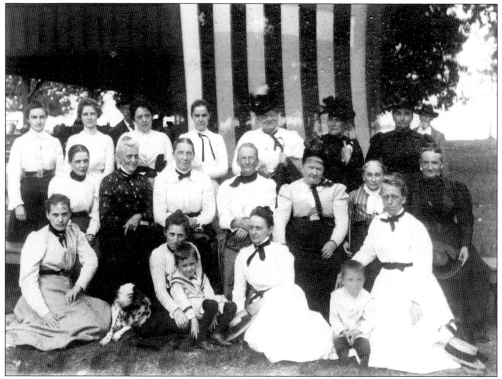

A large flag is the backdrop for this picture of a Grand Army of the Republic ladies' picnic c. 1890. Two children are in front, and two veterans lurk in the background.

This 1925 picture of the Ivy Rebekahs was taken on the front lawn of 200 South Union Street, which was the home of the W. Boyd Moore family and is now the Ogden Senior Center. The Ivy Rebekahs was the ladies group affiliated with the International Order of Odd Fellows.

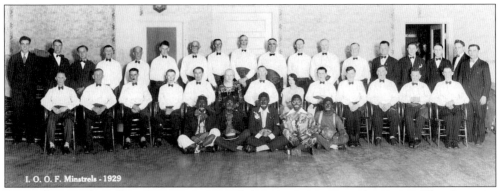

I. O. O. F. Minstrels - 1929

Certainly not politically correct now, minstrel shows were once popular events. This show was performed in 1929 by the International Order of Odd Fellows. The organization lost its meeting hall to a disastrous fire in the 1990s. The site of that building is now occupied by the Spencerport post office.

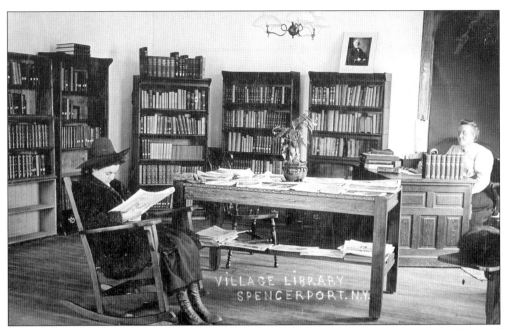

The second floor of the village building housed the Farmers' Library Company of the Town of Ogden (commonly known as the Ogden Farmers' Library). The library was founded in 1817 and operated in a variety of locations throughout the early part of the 19th century until it fell into disuse after the Civil War. Shown in this 1908 photograph are librarian Lovilla Dimock (left) and Harriet Moore. Dimock taught in area one-room schools for nearly 40 years. Moore was instrumental in reorganizing the library and getting it chartered through the New York State Board of Regents in 1908.

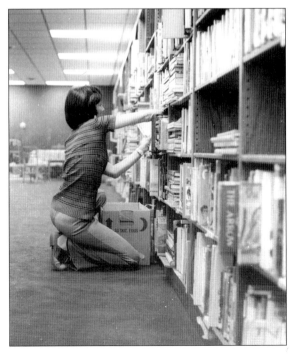

The Ogden Farmers' Library moved from the village building to a new location at 27 West Avenue in the newly built town hall in the mid-1960s. Another move occurred in 1976, when the Village of Spencerport moved its operations from 21 Amity Street to the West Avenue location. The town offices moved from West Avenue to 409 South Union Street, and the library moved to 21 Amity Street. Dorothy Green is pictured helping to unpack and shelve library books.

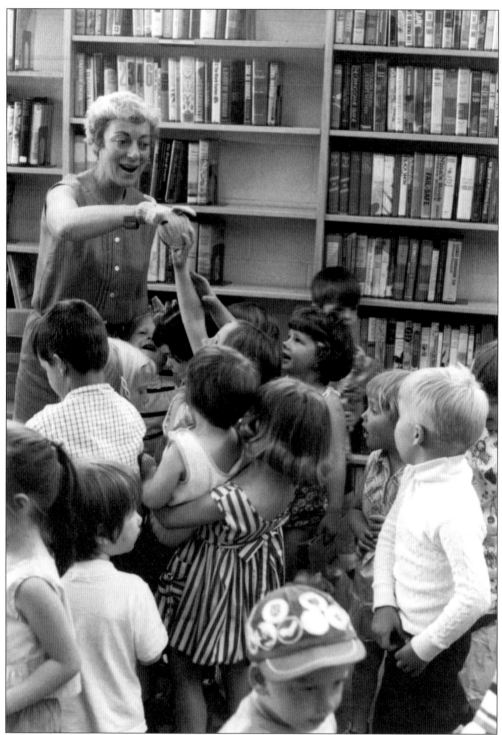

Rosalind "Roz" Krebs is pictured during one of her storytime programs at the library in the early 1970s. She has presented Tuesday morning storytimes at the library for 40 years. Many of the children who attended her early storytimes now bring their own children to the library.

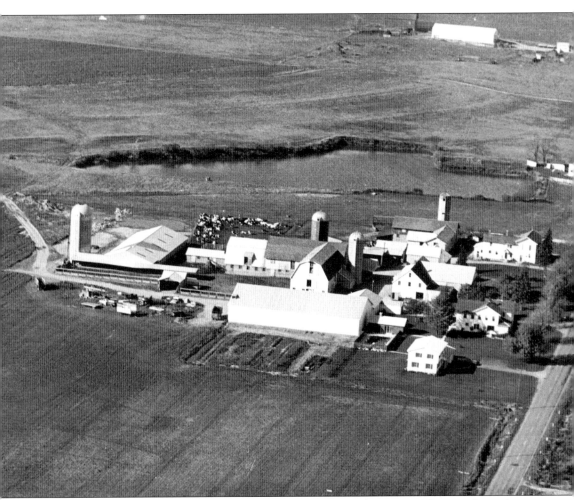

This aerial view looking west shows Colby Homestead Farms. This modern farm operation—run by Charles and Robert Colby, sons of James and Reta Colby—farms acreage originally settled by four Colby brothers who emigrated from Connecticut in 1802. John Colby was the first Caucasian child born in the town of Ogden.

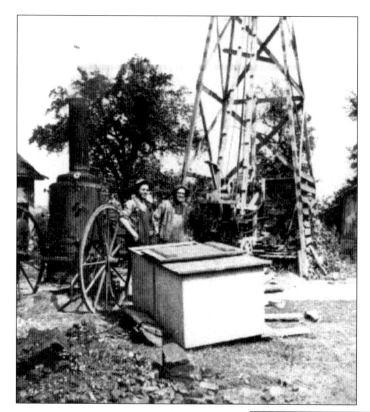

Two of Ogden's 19th-century well drillers, Hiram Smith (left) and Charles New, pose beside their steam-driven drilling equipment c. 1890. Residents of Ogden, like most rural towns, depended on wells for their water needs, so the services of men such as Smith and New were in demand.

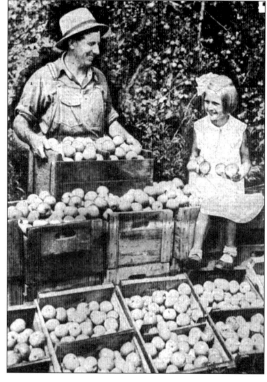

Ogden's orchards produced apples, peaches, cherries, and pears. This picture, taken c. 1920, shows A.E. Weirich and his daughter Mary admiring some of the 20,000 bushels of apples harvested on the Weirich farm in Adams Basin. The Weirich farm spanned several hundred acres and included parts of what is now Northhampton Park.

Beatrice Barclay poses on a ladder in an apple tree at the Weirich farm. The circumstances surrounding the picture are not known, but she does not appear to be wearing shoes suitable for picking apples.

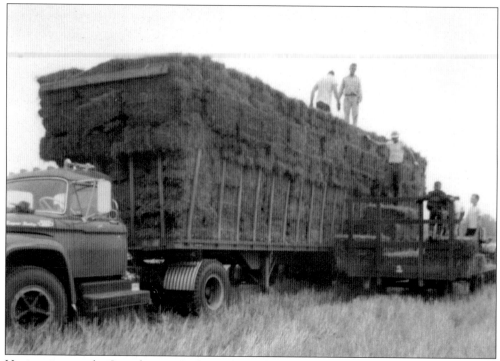

Haying time on the Statt farm in Ogden is shown here. There are many operations like this on farms all over Ogden. Several years ago, farmers from this area responded to the needs of drought-stricken areas in the South and Southwest by sending tons of alfalfa and timothy for relief of starving livestock. New York has consistently been the nation's largest producer of timothy, which ranks with apples and grapes as the largest crops grown in the state.

Eugene Hoy, pictured with wife Jennie Castle Hoy, invented the Hoy potato digger, which was made for a time in Ogden.

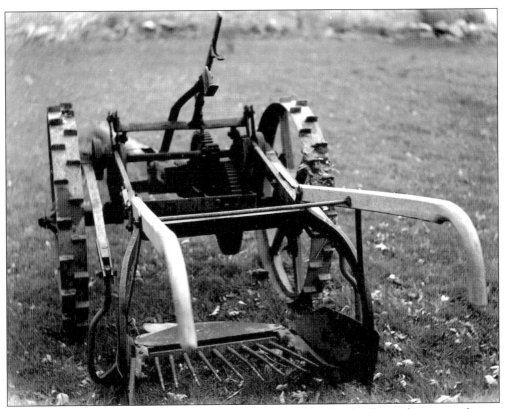

Potatoes have always been an important crop in Ogden. The Hoy family sought to capitalize on that and relieve farmers everywhere of the backbreaking work of digging up rows of potatoes in the fall with the invention of this one-row digger originally designed to be pulled by a horse.

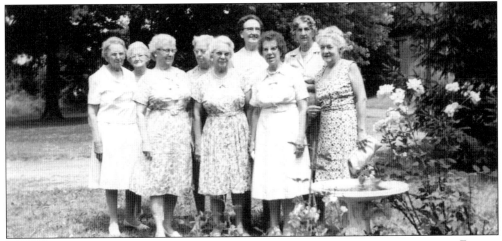

Ogden Home Bureau members pose c. 1960 with Monroe County Home Bureau agent Frances Searles. From left to right are Marguerite True, unidentified, Inez Pulver, unidentified, Eleanor Weirich, Mabel Colby, Helen True, unidentified, and Frances Searles.

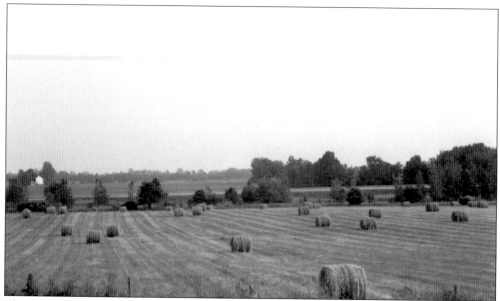

This view looks south from Route 31 (Nichols Street) toward Route 531 and Ogden Center Road. Route 531, a limited-access highway, was completed in 1994. It has substantially shortened the driving distance to the city of Rochester and other parts of Monroe County. The hay bales in the foreground are located on property owned by the Wegmans supermarket chain since 1968.

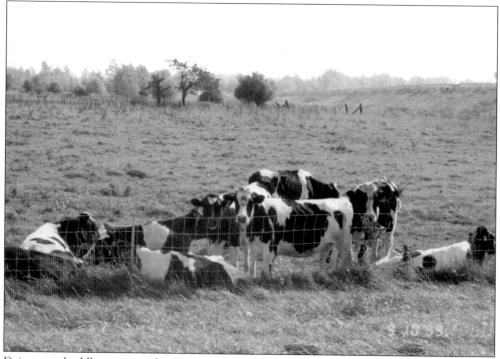

Dairy cows huddle next to a fence near Route 531 in Ogden. Town planners hope to preserve agriculture in the western part of the town. Dairy farms have dwindled from dozens 40 years ago to fewer than 10 today. Those that do exist prosper.

Nine
SPORTS AND
RECREATION

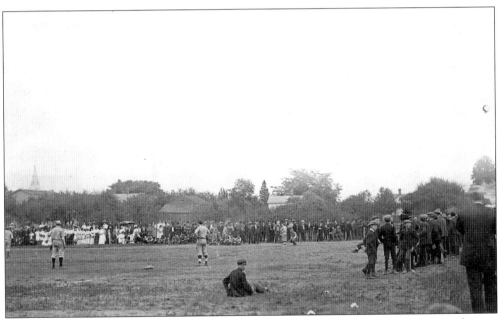

By the early 1900s, Americans began to have enough time away from work to enjoy leisure. Baseball grew in popularity during the 1800s, and two semiprofessional teams existed in Ogden at the time this game was played on September 7, 1906. Spencerport met Adams Basin at a diamond located west of Washington Street and south of Canal Road. Women and men both dressed in their finest to observe these rival teams in action. Adams Basin won the game.

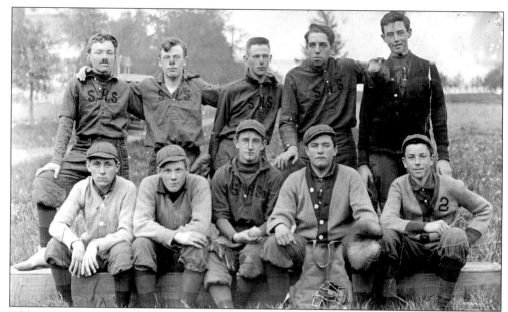

Although their season record has not survived, we know that this team lost the big game to Adams Basin in 1906. Charles Ballard, later police chief for Ogden, was the catcher. From left to right are the following: (front row) Leon Zimmerman, James Lapp, Homer Rogers, Charles Ballard, and Blair Wilcox; (back row) Lester Welch, Irving Hoy, Neil Vickery, Ernest Stettner, and William Dunn.

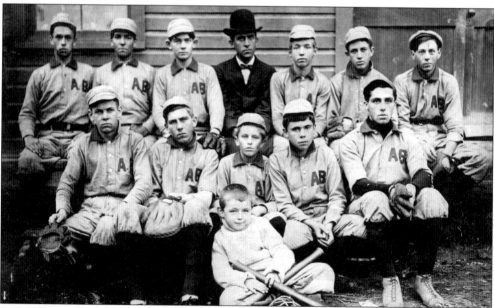

Only a few of the victorious 1906 Adams Basin players are identified in this picture. Sitting in the front is bat boy Francis Ryan. In the front row, Ed Ryan is fourth from the left. In the back row, John Ginther is third from the left and Frank Blackford is fourth. George Mogridge (not pictured) played for Adams Basin in the early years and went on to play professional baseball with the Chicago White Sox, New York Yankees, and the Washington Senators. On April 24, 1917, Mogridge became the first Yankee to pitch a no-hitter.

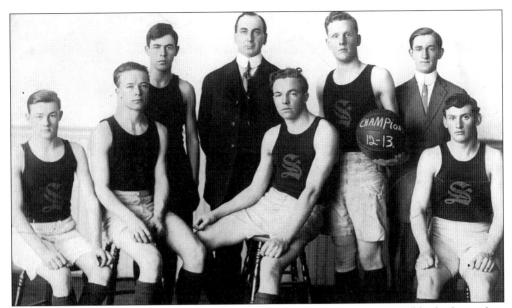

Basketball was invented in the early 1890s in Springfield, Massachusetts, and had taken a firm hold in Spencerport by 1912, as shown in this picture of the 1912–1913 Spencerport High School basketball team. From left to right are Ben Everett, Bus Brown, Harold Dunn, Prof. George B. Marble, Lester Welch, James Lapp, Homer Rogers, and Leo Goodridge. Goodridge, a member of the 78th Division of the U.S. Army, was killed in France in 1918. He and fellow Ogden resident Edward Ferris, also killed in 1918, have their names joined in local history as the Ferris-Goodridge Post of the American Legion, No. 330.

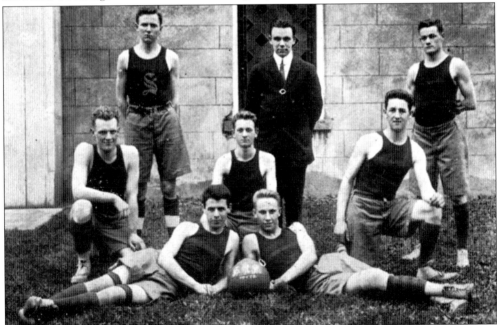

Spencerport's 1915 basketball team was very fast but light. They were at a great disadvantage when playing against teams with heavier and taller players. As a consequence, the team won six games and lost eight that year.

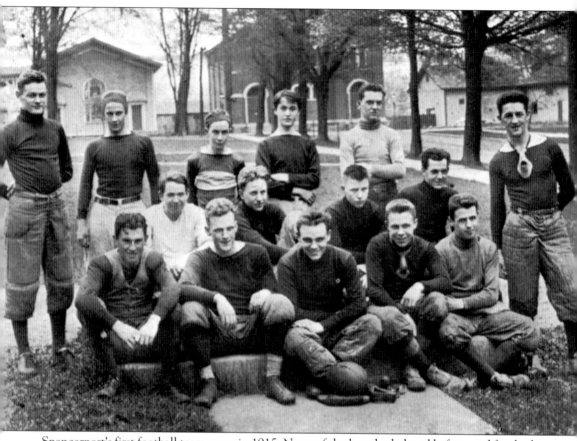

Spencerport's first football team poses in 1915. None of the boys had played before, and few had even seen a game. They lost their first game to Churchville but then won against the same team a week later. Their first-year record was four wins and three losses.

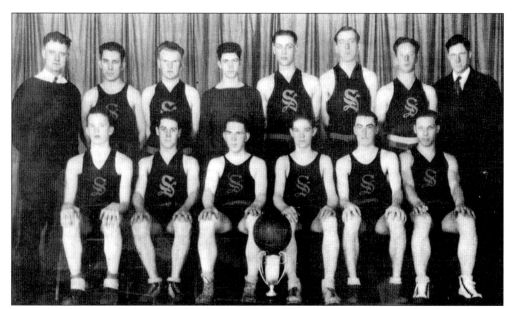

Basketball continued to be a popular sport in Spencerport, as the high school team held the county championship title from 1926 to 1929. Pictured from left to right are the following: (front row) Harold "Haud" Brown, Yale Turner, Willard "Jess" Holbrook (captain), Franklin "Bub" Brown, Arthur Kincaid, and Irving "Moon" Waterman; (back row) Lawrence Rogers (coach), Francis "Bud" VanNest, Leland "Slick" Bennett, John "Tony" Mullaly, Charles "Tillie" Lissow, Hurly "Drips" Drury, Irving "Rusty" Sutherland, and Dr. Gilbert "Doc" Youngs (trainer). This photograph was taken on the stage of the former Spencerport High School, now the Trowbridge Apartments. Coach Lawrence Rogers was later the proprietor of Rogers Flowers, at the corner of Union Street and Upton Avenue.

Spencerport High School's 1932–1933 varsity basketball team won the Western Division easily and then beat Eastern Division champion Webster for the Monroe County title. Star John Lenhart, at six feet five inches, led Spencerport and later played for Colgate University. His father was Dr. Charles Lenhart. Pictured from left to right are the following: (front row) Herbert Calhoun; (middle row) Stub Vickery and Dick Dewey; (back row) John Lenhart, Dom Morabito, Willard "Skid" Kenyon, Irv Brown, and John Cozan.

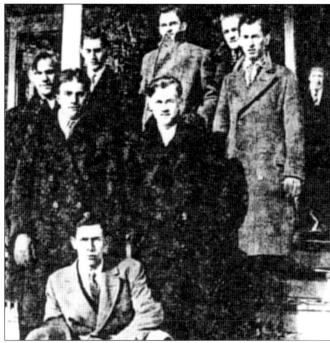

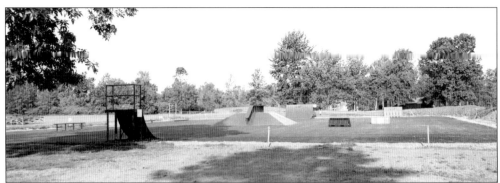

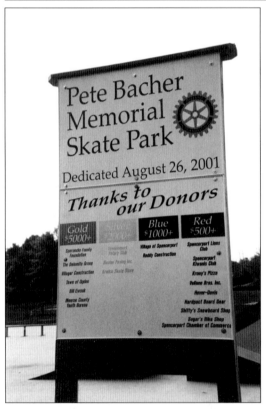

Several years of fundraising resulted in the construction of the Pete Bacher Memorial Skate Park in 2001. Pete Bacher was an early supporter and organizer of the project. The facility is located in Ogden's Pineway Ponds Park.

Ten

PEOPLE AND PLACES

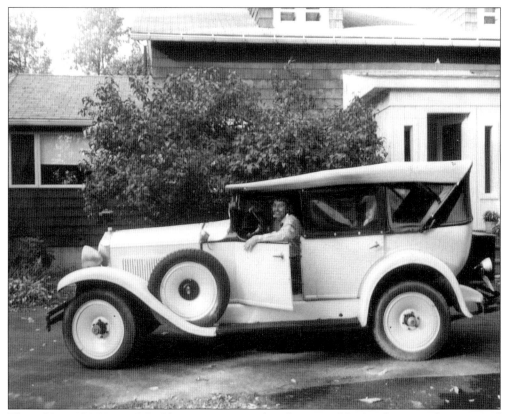

This 1928–1929 Hupmobile Phaeton was owned and treasured by local poet and writer Paul Humphrey; it is now owned by Ken Beaman of Ogden. Humphrey, who died in 2001, enjoyed a post-retirement career as a writer for the local paper, the *Suburban News*. He was also a relative of well-known 20th-century illustrator Maud Humphrey and her son Humphrey Bogart.

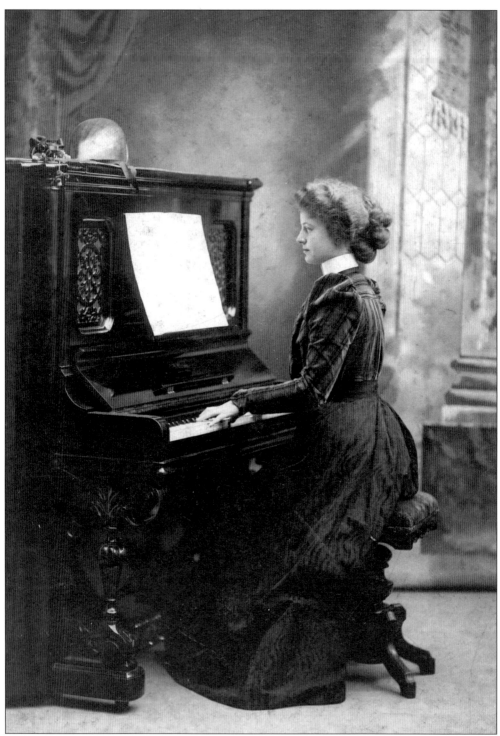

Maude Udell is pictured at the family piano. The Udells were a well-known Spencerport family for many years. The most notable of the homes owned by the Udells was at the southwest corner of Martha Street and West Avenue.

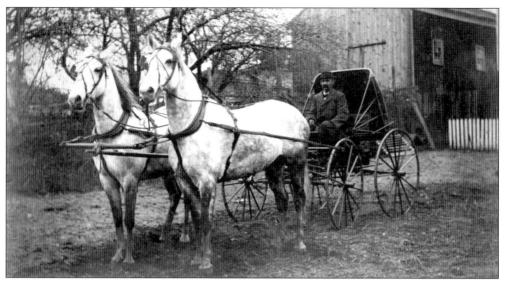

In this 1890 view, George Webster proudly sits in his buggy with two well-groomed horses.

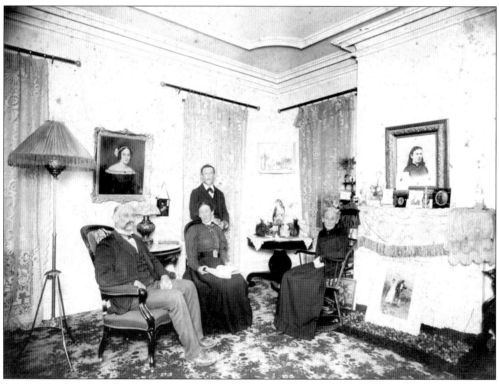

Postmaster Frank Webster and his family pose in their parlor in this early-1900s photograph. The Webster home was located on the west side of Union Street south of Lyell Avenue in the village. Webster served as postmaster from 1907 to 1910. Alexander Colby, son of Oscar Colby, wounded at Gettysburg during the Civil War, served as postmaster from 1915 to 1920. Colby's ancestors founded the oldest farm in Ogden in 1802, and his descendants continue to operate it on Colby Road today.

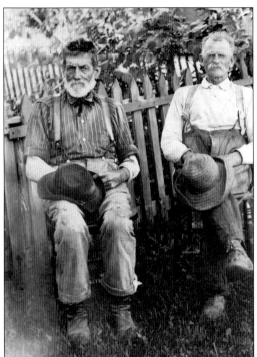

Peter Helfrich (right) poses with an unidentified man in this pre-1900 photograph. Helfrich is listed as a past president (a precursor of mayor) of the village and was also village assessor for a time. Helfrich family members included Philip Helfrich, who ran a hardware store on the east side of Union Street near the former post office. Harold Helfrich ran a small grocery store on Lyell Avenue near Prospect Street. His last store is now used by the volunteer firemen as an office.

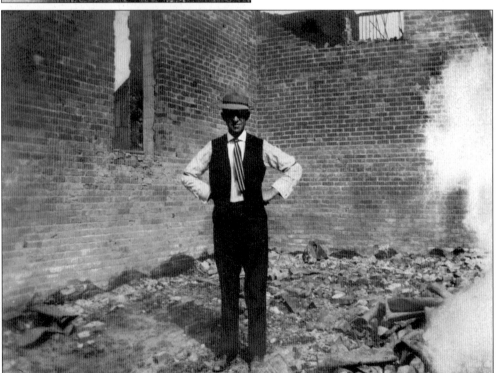

Frank Blackford, a well-known Adams Basin businessman, stands amid the ruins of his fruit warehouse after the disastrous 1909 fire. Blackford later served as U.S. marshal for western New York and lived on Coleman Avenue in Spencerport.

W.S. Milliner, druggist, is pictured *c*. 1910. Milliner was well loved by local children for the free ice cream he distributed at parades. Milliner's Drug Store preceded the Austin Drug Store and was located on the west side of Union Street in the Masonic Temple building. Members of the Austin family, followed by Robert Sickelco, provided drugstore services to the community through the 1980s.

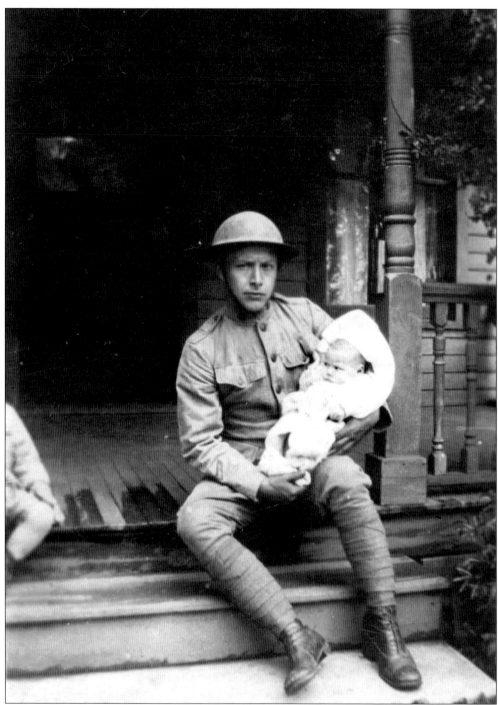

Harold "Nick" Hoy is shown holding his two-month-old daughter, Winifred, on Memorial Day 1926. He is wearing his World War I uniform and marched with other veterans in the parade that day. Hoy was wounded in France in 1918 and became an active firefighter with the Spencerport Volunteer Fire Department upon his return. He served as mayor of Spencerport in the 1940s.

William B. Moore, pictured in the early 20th century, operated a business at 194 South Union Street, where the Ogden Senior Center is currently located. His son W. Boyd Moore expanded the business into a coal and feed distributor and constructed the building at the corner of Slayton Avenue and South Union Street, currently used as a veterinarian's office. His granddaughter Helen C. Moore operated an insurance agency on Nichols Street and served as a member of the Ogden Town Board in the 1980s.

Mabel Allen, daughter of Hank Allen, poses for the Eastman Kodak Company in the 1920s. Mabel was one of the fortunate ones who sought jobs as Kodak models in the box camera days.

Harry Noble is shown here at Nobles Pond. Ice was cut from the pond for refrigeration purposes, but the pond was also a favorite spot for area children and adults to ice-skate in the winter months.

Dr. Knox Brittain is pictured with his wife, Sunny. Dr. Brittain is credited with being a founder of the Spencerport Volunteer Ambulance service. He and his family, including sons Bob and Bill, lived on Lyell Avenue east of Union Street. Dr. Brittain was the chairman of the village planning board for many years, and his name is perpetuated in Brittain Circle, a street in the western part of the village. Brittain's son Bill authored several children's books, including the Newbery Honor book *The Wish-Giver*.

Earl Austin is pictured in the early 1930s in front of his home on South Union Street during a typical Spencerport winter. Earl and his brother W. Ray Austin operated Austin's Drug Store for many years. Dale Austin, Earl's nephew, ran a drugstore farther south on Union Street during the 1980s.

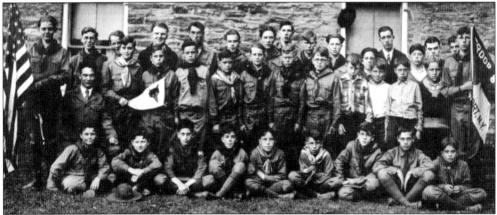

Boy Scout Troop 84 poses in 1925. Many members of this troop went on to become prominent citizens in the town and village. Those pictured are, from left to right, as follows: (front row) Albert "Boots" Lieutwilder, Herbert Smith, Dominic Morabito, Gordon Gillette, Edward Church, John Thomas, Gilbert Spencer, Lawrence Hawley, and Robert Vickery; (middle row) Arnold Austin, Russell Fraize, Raymond Elliott, Tom Jim Mullaly, Ralph LaBorie, Clifford Vroom, Richard Dewey, John "Geezer" Osborne, John Betts, Fred Crockenberger, Gerald "Jeff" King, and Carl Phillipson; (back row) Wilson Trimmer, Udell Stone, Irving Brown, Leland "Bean" Bennett, Arthur Kincaid, Marshall Brooks, David Bromley, Arthur Helfrich, John Lenhart, Gilbert Ross, Edward Spencer, Hurly Drury, Richard Turpin, Lester Kincaid, Anthony Mullaly, and David Donnan.

Local legend Dr. Charles Lenhart is shown here addressing a Spencerport group. Rev. Donald Creech, pastor of the Spencerport Congregational Church, is to the far right. Lenhart lived and had his office at the southwest corner of Union Street and Lyell Avenue, a home now owned by Charles and Cynthia McCloskey. Floretta (Lenhart's wife), son John, and daughter Lorraine were a prominent local family. John, a six-foot-five-inch basketball star, led Spencerport High School to many victories in the 1930s and later played for Colgate University.

Inez Pulver is pictured in the late 1960s before she and her family were forced to vacate their 151-year-old home on Colby Street when Monroe County took possession of the property as part of Northhampton Park. The Pulver house, now the Ogden Historical Society headquarters and museum, was built in 1811 and was originally owned by James Wadsworth, an early pioneer and landowner in western New York.

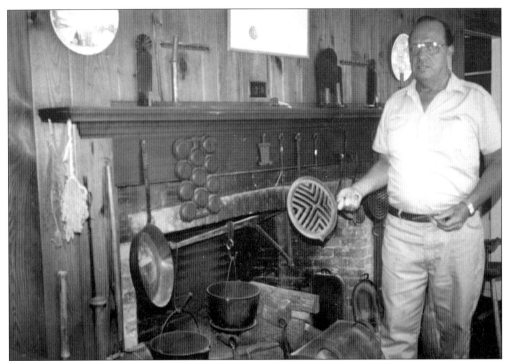

Ted Rogers, president of the Ogden Historical Society, is shown in the Pulver House. The 1967 sesquicentennial commemorative plates hang on the wall in the background. Art and Inez Pulver raised Merle, Dale, and Mary Lou Pulver in the house on the north side of Colby Street just west of Washington Street. The house now serves as the historical society's museum and is open to the public on Sunday afternoons.

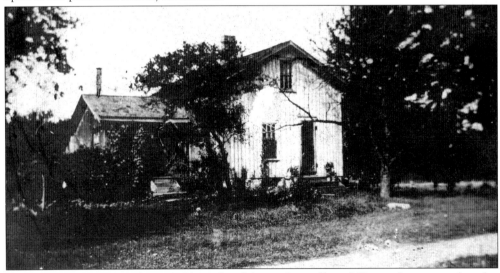

The McCleery homestead on McCleary Road (note the spelling difference) is pictured in this late-1800s photograph. Thomas McCleery and his wife, Catherine, emigrated from Cavan, Ulster County, Ireland, through Port Hope, Canada, to Ogden c. 1860. They raised eight children and sent all of them on to college-level training by selling off parcels of his farm. Many of the McCleery children became schoolteachers.

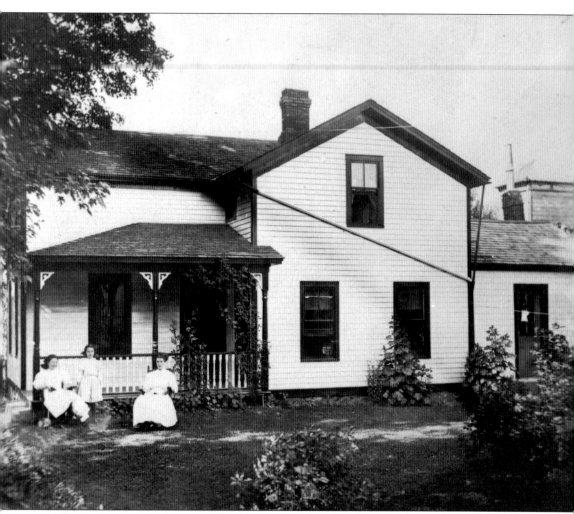

The Cosgrove home is pictured in 1908. The family was a prominent one locally. Daughter Ada was a schoolteacher and vice principal at Spencerport High School. Daughter Grace was an active member of the First Congregational Church. The building is still located on the east side of Bowery Street in the village.

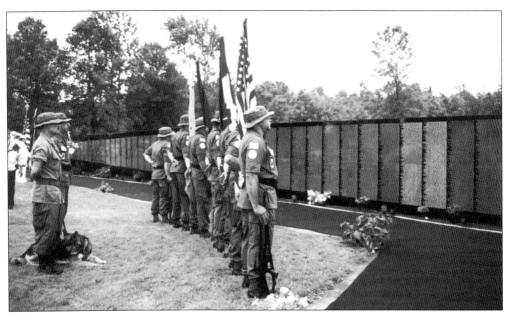

The Ferris-Goodridge Post of the American Legion, No. 330, hosted the Vietnam Veterans Moving Wall in 2000. Veterans are shown here paying their respects. The post is located on the west side of Trimmer Road at a spot once occupied by a one-room school. Trimmer Road was designated a POW-MIA memorial highway by Monroe County. The post name honors Edward Ferris and Leo Goodridge, both from Ogden, who died of combat wounds in France in 1918 while members of the U.S. Army.

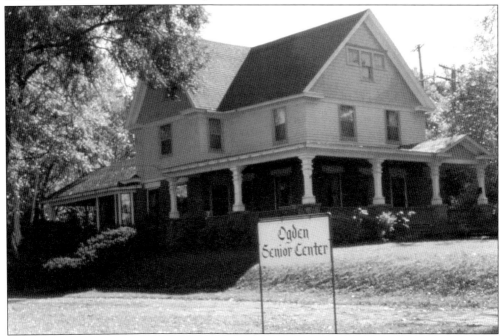

The Ogden Senior Center, located on South Union Street, is pictured here in 1983. The property, including the house and six acres of land, was purchased c. 1899 by William C. Moore. His son W. Boyd Moore started a general insurance business in 1906 at the age of 16.

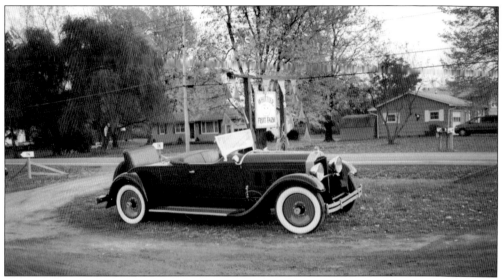

The Beaman 1929 Packard is shown here at Whittier Fruit Farm in 2000. The Packard was a gift to a high school graduate in LeRoy, New York. It was purchased by Charles Beaman in 1949 and has been in the town of Ogden ever since. The Beaman brothers restored this and many other automobiles, including two 1937 Packards—a convertible and a seven-passenger limousine. The Beamans would love to see an automotive museum built in the town of Ogden or nearby Clarkson, which was the boyhood home of George Selden, who patented the first automobile.

Paul and Anthony Montanaro pose for their grandparents, Carole and Dick Palmer, in this late-1990s photograph. Attractive signs such as this one have been placed north and south of the village, along Union Street and on the north side of Route 531. The signs welcome travelers into the friendly community.